Guide to Photographing Birds

Harold Stiver

Guide to
Photographing Birds

Copyright 2014

Harold Stiver

Version 1.0

ISBN #978-1-927835-13-5

Photo Credits

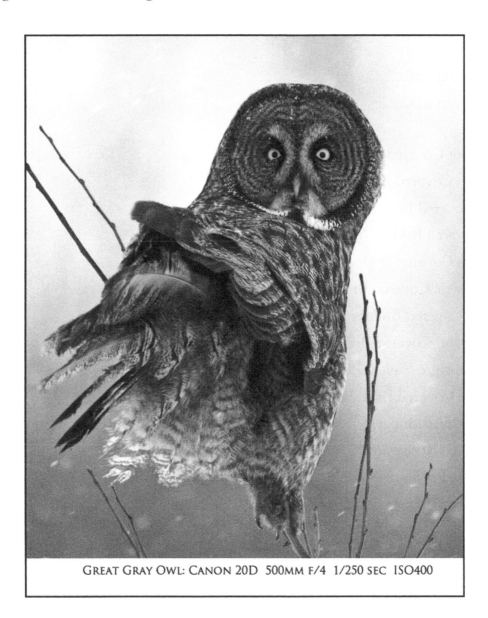

GREAT GRAY OWL: CANON 20D 500MM F/4 1/250 SEC ISO400

Other Books by Harold Stiver

Unless noted, there are Print and eBook editions available for the following.

Birding Guide to Orkney

Ontario's Old Mills
Ontario's Waterfalls

Connecticut Covered Bridges (eBook)
Delaware's Covered Bridges (eBook)
Indiana Covered Bridges
Maine Covered Bridges (eBook)
Maryland's Covered Bridges (eBook)
Massachusetts Covered Bridges (eBook)
Michigan Covered Bridges (eBook)
New England Covered Bridges
New Hampshire Covered Bridges
New York Covered Bridges
Ohio's Covered Bridges
The Covered Bridges of Kentucky (eBook)
The Covered Bridges of Kentucky and Tennessee
The Covered Bridges of the Mid-Atlantic
The Covered Bridges of Tennessee (eBook)
Vermont's Covered Bridges
The Covered Bridges of Virginia (eBook)
The Covered Bridges of Virginia and West Virginia
The Covered Bridges of West Virginia (eBook)

Index

Introduction

Some of the most beautiful and interesting nature images are of birds and it is no surprise that photographers want to explore that area. However, they are often disappointed with their initial results. The subjects look small in the image, poorly lit and a bit boring. I want the information in this book to get you past that to the beautiful images you will be proud of.

Birds can be the most frustrating of targets. When they are seen, they are often very wary and not easy to get close to. Even after getting an image, the results may be unsatisfying. Don't give up!! This book will give you the tips and techniques that will let you get close to these elusive subjects.

However before we get to that, we will talk about camera equipment and settings.

And before we finish we will pass on some ideas about processing your images to bring out their best.

So lets get started!!

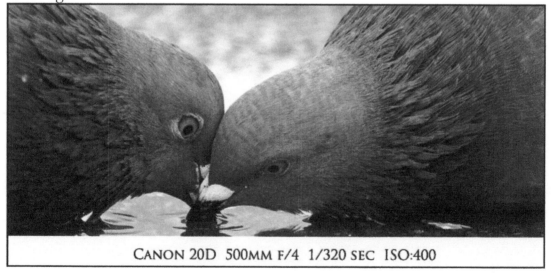

CANON 20D 500MM F/4 1/320 SEC ISO:400

Equipment to use

The first thing to understand about equipment is that you don't need to have the latest and most expensive gear there is to obtain good bird images. Of course, better equipment will make it easier for you but a lot of excellent images have been made using methods like digiscoping where a Point and Shoot digital camera is used in connection with a spotting scope. More about this later.

CANON 5D2 500MM F/4 + 1.4X
1/60 SEC ISO:400

Most photographers are going to use DSLR cameras which involve separate camera bodies and lens.

Camera Bodies

Even the lowest line of current camera bodies will provide photographers with an excellent tool at a reasonable price. The Canon Rebel T3 is less than $500. Other popular brands like Nikon have similar equipment with excellent value. From there you will arrange all the way up to professional camera bodies like the Canon 1D or the Nixon D3x at over $6,000. The higher quality body will do things like take 10 frames per second as opposed to 3, do a better evaluation of the correct exposure better, and have a faster and more accurate focusing systems. It also will shoot HD video which can be very useful.

A large number of bird photographers use either Canon or Nikon equipment. As of 2013 the following prices applied to DSLR Camera Bodies:

Economy

Canon Rebel T3 $500
Nikon D5100 $600

Professional

Canon 1D $6,800
Nikon D3x $6,700

GREAT BLUE HERON: CANON 20D 100-400MM F/5.6 1/400S ISO800

Lenses

A 300mm lens will start to do the job, especially if you combine it with a teleconverter to get you closer. A teleconverter is an intermediate lens which magnifies the image. A 1.4 teleconverter gives a 300mm lens the reach of 420mm. Canon and Nikon also makes a 2x teleconverter although it can be more difficult to get sharp images

with this combination. You should think about the longest lens your budget will allow. I usually use a Canon 500mm lens. It is the most expensive piece of camera gear I have but it pulls the subject right in, and it is very sharp. On the downside, it is heavy and a bit awkward to use and it requires a heavy duty and expensive tripod support.

As of 2014 the following prices applied to DSLR Camera lenses:

Teleconverter

Canon 1.4x	$500
Canon 2x	$500
Nikon 1.4x	$400
Nikon 2x	$500

Telephoto Lenses

Canon 100-400mm zoom	$1,700
Canon 300mm f/4.0	$1,450
Canon 400mm f/5.6	$1,400
Canon 500mm f/4.0	$10,300
Canon 600mm f/4.0	$12,800
Nikon 200-400mm Zoom	$6,500
Nikon 300mm f/4.0	$1,370
Nikon 400mm f/2.8	$9,000
Nikon 500mm f/4.0	$8,400
Nikon 600mm f/4.0	$9,200

A bit intimidating isn't it! Bear with us though and we'll put together a reasonable starter kit later on.

BLACKBURNIAN WARBLER:
CANON 20D 500MM F/8
1/250 SEC ISO200

Tripod

While it is not always possible to use a tripod when photographing birds, when it is, it is very beneficial. Since we are going to use a big lens, any camera movement readily translates into less sharpness in images. The heavier the tripod, the greater the stability. In addition to the tripod you will need a tripod head. A good ball head will be useful for mid size lenses. For heavier lenses the Wimberly heads are very popular and useful. Check on-line for further information.

Tripods $150 and up depending on load weight.

Tripod Heads

Quality Ball Head $100 and up

Wimberly Head $600

Wimberly Sidekick $250 (Needs to connect to a Ball Head)

All of these systems use Quick Release Plates which connect to the lens (or to the camera body when using small light lenses)

Quick Release Plates$40-$60 depending on the weight of camera and lens

You might also benefit from a tripod you can use from your vehicle. More about this later.

CHESTNUT-SIDED WARBLER:
CANON 5D 500MM F/5.6
1/40 SEC ISO400

your flash to project the light farther. The cost of flash units varies by features such as recharge rates and wireless capability. Many DSLR cameras have a flash unit included but the telephoto lenses used often block part of the flash, leaving the image unevenly lit. They also do not throw the light as far separate flash units do.

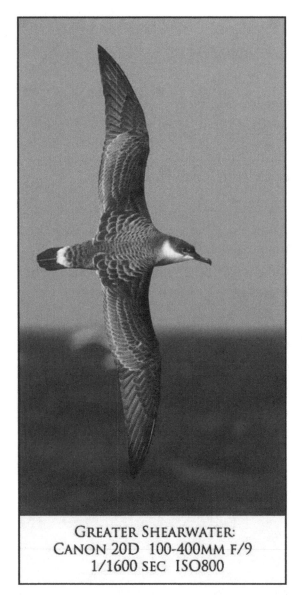

GREATER SHEARWATER:
CANON 20D 100-400MM F/9
1/1600 SEC ISO800

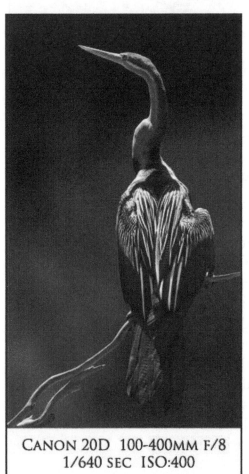

CANON 20D 100-400MM F/8
1/640 SEC ISO:400

Flash

Like the tripod, flash can only be used in limited circumstances. When you can use it, adding a Better Beamer to your flash will much improve your system. It is a plastic Fresnel lens which attaches to

Flashes

Canon Speedlight 600EX	$550
Canon Speedlight 430EX	$260
Nikon Speedlight SB-910	$550
Nikon Speedlight SB-700	$325
Better Beamer Unit	$35

Memory cards

This section will probably be out of date by the time I finish typing but you can get a 16 gb Compact Flash card for about $50. These seem to be getting larger capacity and cheaper all the time. I usually have 4 or 5 cards with a total capacity of 60-80 gb, more than enough to cover an intensive day of shooting. Everyone develops their favorite brand but Lexar and Sandisk are popular.

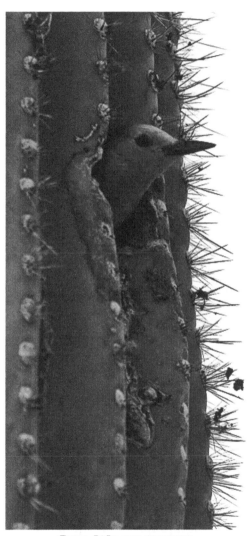

GILA WOODPECKER:
CANON 5D 500MM F/5
1/800 SEC ISO400

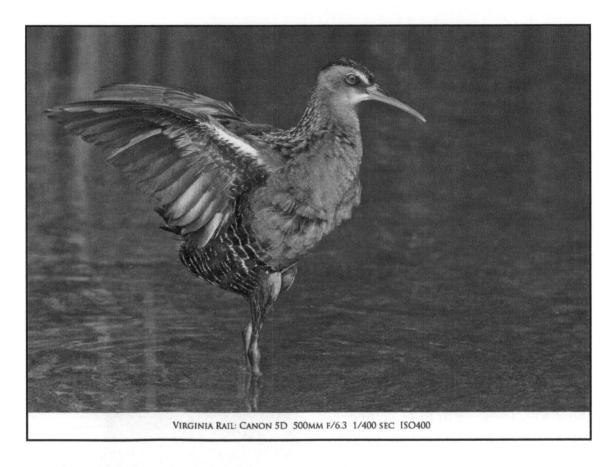

VIRGINIA RAIL: CANON 5D 500MM F/6.3 1/400 SEC ISO400

A Starter Kit

Have you gotten over the sticker shock of prices in our equipment section? Lets see what it would cost to put together an economic kit to get started in bird photography.

Lenses are the part of the system we want to be generous with. While your camera bodies and other equipment may well be changed through the years, a good lens is a lifetime investment. They also hold their value and you can realize good prices if you decide to sell them. If we look at Canon Lens, the Canon 100-400mm zoom or the Canon 400mm f/5.6 are both lower priced telephoto lens which are of excellent quality. The Canon 100-400mm zoom is more versatile and allows you to compose various images by moving the zoom. The Canon 400mm f/5.6 is probably a bit sharper and quicker to focus as well as being lighter but doesn't have the flexibility of a zoom.

For the camera body the Canon Rebel T3 will be excellent to start with. If later on you should decide to upgrade, it will make a great backup camera. Camera bodies tend not to hold a lot of value for resale. Add a 16 gb Memory card.

The weight of the Canon 400mm f/5.6 and Canon Rebel T3 is under 2 kg. You could go for the Manfrotto 190 Tripod which is rated for 5 kg. and add a Oben BA-1 Ball Head which is for 8 kg capacity and includes its own quick release plate.

Canon 400mm f/5.6 $1,400

Canon Rebel T3 $500

Canon 1.4x Teleconverter $500

Canon Speedlight 430EX $260

Manfrotto 190 Tripod $155

Oben BA-1 Ball Head $70

16 gb memory card $50

Total= $2,935

If this is more than you want to invest, or you want to have some experience with it before you put out a lot of money, you can try some of these approaches. Buy only a camera, lens and card:

1) Use third party lens. Companies like Sigma and Tamron make lens to fit camera bodies like Canon and Nikon. The quality varies but some are surprisingly good and inexpensive. You will need to do your homework but the internet waits on your command.

2) Buy used equipment. Look at eBay, camera stores or photography forums. You run some risk of getting problem equipment of course but there often is value, especially with used camera bodies.

3) If you have a birding scope consider digiscoping. More in our next section.

Using this approach, you might be looking at the following costs:

Third party or used 400mm $500 or less

Canon Rebel $150

Transcend 16 gb memory card $15

Total= $765

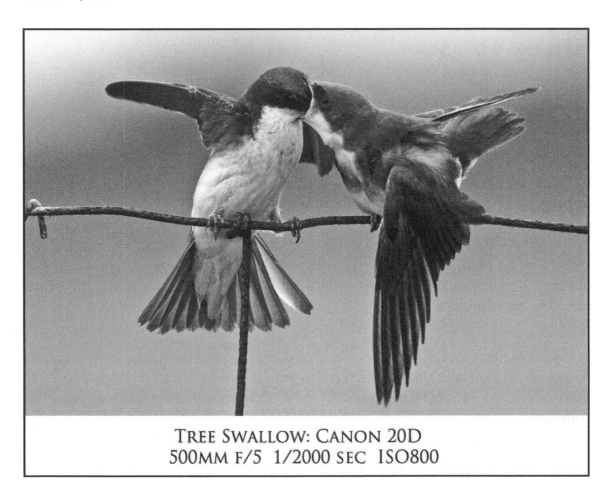

TREE SWALLOW: CANON 20D
500MM F/5 1/2000 SEC ISO800

Digiscoping

Digiscoping is a process to produce images by using a Point and Shoot camera in combination with a spotting scope. This can be done by using an adaptor to connect them or by hand holding the camera against the eyepiece of the scope.

I first became interested in bird photography after trying this method many years ago. At that time it was an almost unknown method and we had to work out the problems as we went along. That is not a complaint as it was very exciting and I learned a great deal about what solving problems in photography.

Nowadays this is a well established procedure with huge numbers of people trying their hand at it. For a newcomer, there are a great deal of online resources to help you get started and you can find experienced people to provide advice.

If you already have a spotting scope, you only need a Point and Shoot camera to complete your setup. You may also want an adaptor to connect them. Finding the right adaptor or making your own, can be complicated. You need one which will set the lens of the camera flush and parallel with the eyepiece of the scope in a way that causes minimal vignetting.

Advantages

1) Inexpensive if you already have a Spotting Scope

2) Greater telephoto length (Equivalent to a 1200mm lens or greater)

Fabulous photos are produced every day with this technique.

Disadvantages

1) Some of the functions of the camera like auto focus or auto exposure may be fooled by the introduction of the scope in the system. Manual adjustment can correct this.

2) Since the lenses of the scope may not have been designed for photography, they may create image defects such as chromatic aberration or color fringing. They are ways to fix this in editing but they are not always easy.

3) Images of birds in flight are very difficult

4) Point and Shoot Cameras often have shutter lag, a significant time between triggering the shutter and when the photograph is actually recorded. During this time, your subject may move.

Look in the Resource Section for further information.

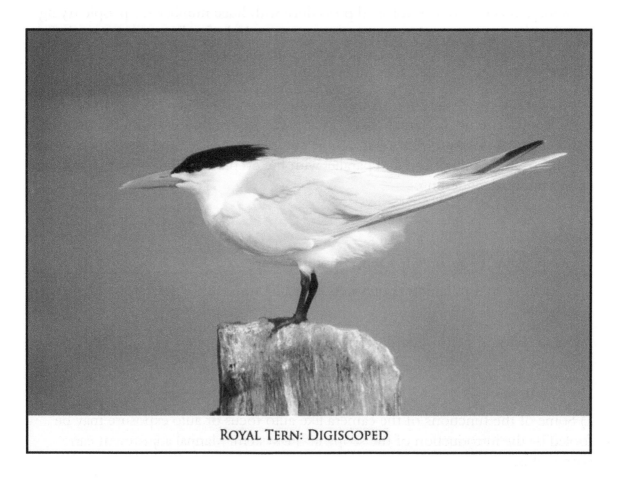

ROYAL TERN: DIGISCOPED

Camera settings

BROWN-HEADED COWBIRD:
CANON 20D 500MM
F/7 1/200SEC ISO400

Our camera settings are dependent on our subject, what it is doing and the amount of light it is in. If we can deal with difficult conditions, we should have little trouble with easier ones.

We need to set our camera so that the available light reveals the situation, that we have enough depth of field so that all of the subject and surrounding elements are in focus, and that the resulting image has a minimum of noise.

The first thing about getting things right with your camera is to have knowledge about, make sure you know it well. Read your manual, understand what the various settings are and practice adjusting them.

As a practical matter, learn how to make adjustments without looking at your camera. If you have to take your eye from the viewfinder to make adjustments you will miss shots. Being able to make these adjustments while you have your composition ready is invaluable.

Of particular importance, be sure you can change shutter speed, Depth of Field (F-stop) and Exposure Compensation (+,-) on the fly.

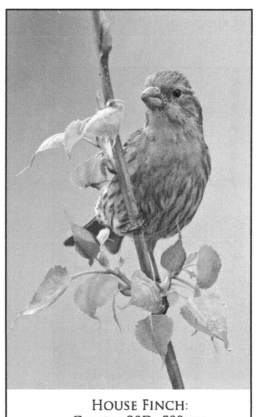

HOUSE FINCH:
CANON 20D 500MM
F/7 1/250SEC ISO400

Shutter Speed

The first thing we need to deal with is making sure that we have sufficient shutter speed to ensure that our moving target is not blurred. If your image is dark or has a lot of noise, there are measures you can take in editing to fix or improve but their is no fix for blur from a moving subject. Even a subject who is standing stationary will often make quick head movements. It is possible to get good images using a shutter speeds lower than 1/50th/second but it is ideal to use shutter speeds of 1/1000 second or higher.

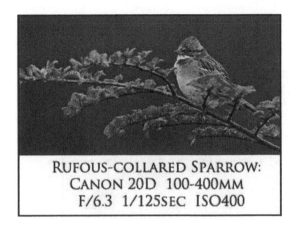

RUFOUS-COLLARED SPARROW:
CANON 20D 100-400MM
F/6.3 1/125SEC ISO400

Depth of Field

Our next priority is Depth of Field (DOF). This is highly dependent on how close your subject is to you, the closer you are, the larger the depth of field you need. If you can reach f/10 as a setting, you will generally be in good shape but consider your local situation. Other factors are the size of the target and how much of the immediate area around it you wish to have in focus. There are also many times we want to minimize the depth of field to include the subject and to otherwise blur the background. This intentional blur of distracting backgrounds is known as bokeh. Look at bird images you admire and you will often see a beautifully blurred background which set off a highly focused subject.

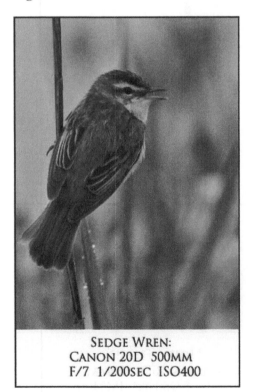

SEDGE WREN:
CANON 20D 500MM
F/7 1/200SEC ISO400

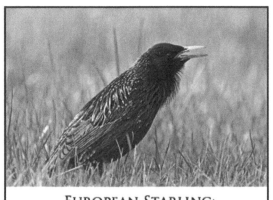

EUROPEAN STARLING:
CANON 20D 500MM + 1.4X
F/7.0 1/100SEC ISO320

ISO Setting

The ISO setting determines how much noise you will have in your image. This is much less of a problem than it used to be. Most modern cameras handle noise very well and we will discuss processing tips to reduce it further if necessary. If you can get sufficient shutter speed and DOF at 400 ISO, you should be in good shape but if necessary, you can crank it much higher.

Mode

Most bird shooters use Manual, TV or AV Mode. These modes may give some automatic functions but allow the photographer to exercise a lot of control. TV Mode in which you set the shutter speed and the camera changes the aperture to what it calculates is best exposure, is probably the least useful of these, as you want to be in control of the depth of field yourself.

Exposure Compensation

The first thing a new bird shooter notices when he take an image of a bird is that it commonly turns out too dark or,more rarely, too light. The exposure set by the camera is not right. While this can sometimes be corrected in editing, it is best to learn to use the proper exposure in the first place.

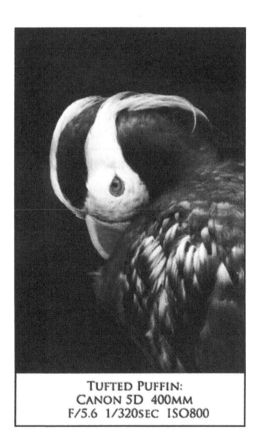

TUFTED PUFFIN:
CANON 5D 400MM
F/5.6 1/320SEC ISO800

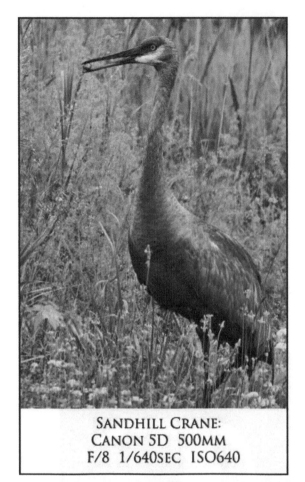

SANDHILL CRANE:
CANON 5D 500MM
F/8 1/640SEC ISO640

sky and an underexposed subject. This is a very common shooting situation and you want to learn what exposure compensation works with this situation and your setup. You may find that you will need to set the exposure for +1 or more. This is easy to test by using the limb of a tree to experiment with.

An easier way is to set your camera to overexpose for what it calculates and therefore get the correct exposure for your subject. You will find that you need to set your exposure for +2/3 of a stop or greater. Again, test this by having a tree limb or pole in the image and see how the detail is and adjust from there.

When photographing birds we want to correctly expose for the bird itself. Many cameras have spot metering whereby you can pick a small part of the frame to choose for your exposure. If your camera has this feature, learn to use it. Often however it is not practical and in these situations, you can set the exposure yourself. For example, if you let your camera set the exposure for a bird with a light sky as background, you will often end up with a nicely exposed

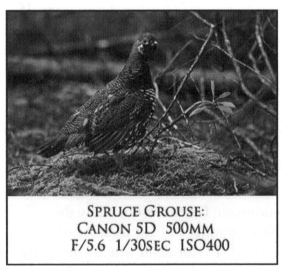

SPRUCE GROUSE:
CANON 5D 500MM
F/5.6 1/30SEC ISO400

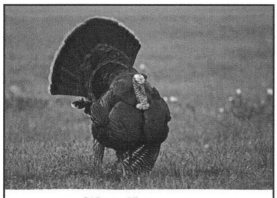

WILD TURKEY:
CANON 5D 100-400MM
F/6.3 1/80SEC ISO400

Focusing

The autofocus has been getting better and better on DSLR cameras in the last few years. The camera should be set to either AI Focus or AI Servo mode. Many photographers feel AI Servo is more accurate for moving targets. Look under our section on technique to get tips on ways to improve your focus results.

Your camera will probably allow you to set the AF point or points. Many photographers set only the centre point as active while others prefer multiple points. Results may vary between cameras, so experiment and find the setting you prefer.

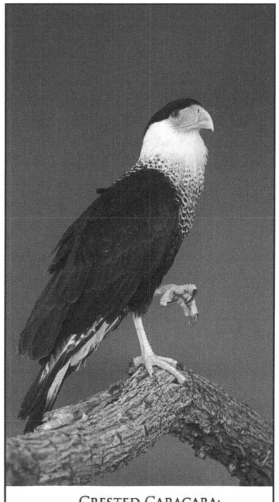

CRESTED CARACARA:
CANON 5D 100-400MM
F/5.6 1/125SEC ISO400

Long Lens Technique

The people who rent large telephoto lens report one common complaint. The customer finds his resulting images are blurry.

Even photographers who have had a great deal of experience with smaller lens can find this problem. many blame the results on the lens but long lens are often the sharpest that manufacturers make.

The real reason is simple. Camera vibration causes blur and the longer the lens the bigger the blur. A 400mm lens will have an image blur that is 20 times what a 20mm lens does for the same amount of camera vibration.

If you want to get excellent detailed images, it is imperative to learn good long lens technique.

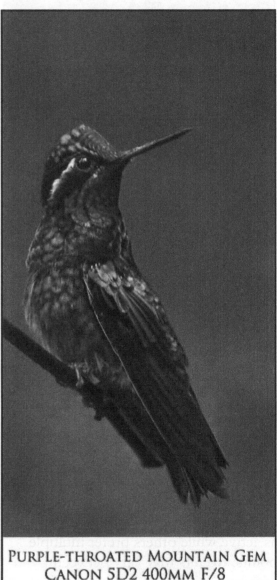

PURPLE-THROATED MOUNTAIN GEM
CANON 5D2 400MM F/8
1/125SEC ISO800

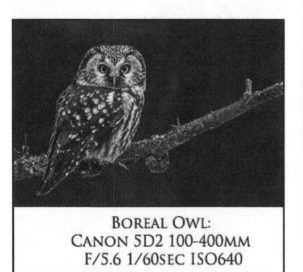

BOREAL OWL:
CANON 5D2 100-400MM
F/5.6 1/60SEC ISO640

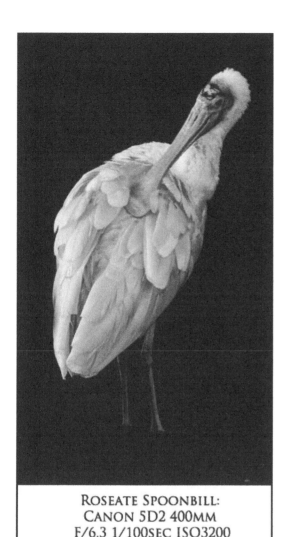

ROSEATE SPOONBILL:
CANON 5D2 400MM
F/6.3 1/100SEC ISO3200

image because they pass the light through more glass. More than that they increase the susceptibility to camera shake. On the other hand, the resolution of cameras has gotten larger through the last few years. Ten years ago, I used a Canon 10D which produced an image which is a bit more than 6 Mpix while currently I often use a Canon 5D2 which is 21.1 Mpix. This gives me much more range to crop a picture than I used to be able to. Also you can enlarge an image and I believe that enlarging an image by 1.4 times gives a better result than using a 1.4X teleconverter. Try testing your own equipment, I think you may be pleasantly surprised.

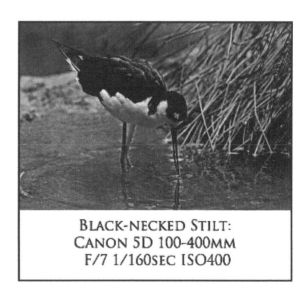

BLACK-NECKED STILT:
CANON 5D 100-400MM
F/7 1/160SEC ISO400

Faster shutter speeds

Under the section on camera settings, we recommended trying to work with a minimum speed of 1/1000 second. The faster your shutter speed, the less your image will be affected by camera shake.

Don't use a teleconverter if you don't need to. Teleconverters degrade an

Use image stabilization

Image stabilization is a family of techniques used to reduce blurring associated with the motion of a camera during exposure. It compensates for pan and tilt of a camera or lens. If you have this function on your camera body or lens, by all means use it. It works.

What about using Image Stabilization when you are using a tripod? Most sources say don't but I give it a maybe. At one time it was important to turn it off when using a tripod but the latest generation of instruments can be used with success on a tripod. You need to check what the situation is with your equipment.

GUIRA CUCKOO:
CANON 20D 100-400MM
F/5.6 1/320SEC ISO400

BLACK OYSTERCATCHER:
CANON 5D 100-400MM
F/7 1/25SEC ISO400

When using a tripod, go heavy and solid.

With a heavy telephoto lens and accessories, a lightweight tripod is not effective In fact with some wind, you may find your valuable equipment on the ground. To increase the stability, you can try hanging a weight from the centre post. Another very useful technique is to use your left hand on top of the lens, pressing down. Even a gentle pressure will eliminate shake.

COMMON SNIPE:
CANON 20D 500MM
F/5.6 1/640SEC ISO400

When not shooting a moving target, tighten your tripod up. If there is no need for lens movement, make sure there isn't any.

A monopod is better than no pod

Take a cue from sportshooters! A monopod can give you plenty of freedom of movement but still give you that bit of extra stability. Its certainly not as stable as a tripod but its a lot better than handheld.

Activating the shutter

This is an area that is often overlooked by photographers. Don't just mash your finger down when its time for your shot, gently roll your finger across the button. It should almost be a surprise when it fires.

Shield from wind

You already watch the position of the sun to keep out the glare. Keep track of the wind as well. If you can shoot from a position that shelters you, you can reduce unwanted camera movement. Even getting lower can make a big difference.

Shooting handheld

If you are shooting without a tripod, you want to make yourself a tripod. Keep your elbows tucked beside your body and your feet apart. Hold eyecup lightly pressed to your forehead. Take advantage of items around you. Resting the lens on a log or fence will help and even leaning against a tree will make a difference.

HORNED GREBE:
CANON 5D 500MM+1.4X
F/6.3 1/640SEC ISO400

Panning

Panning involves moving your camera to match the motion of your subject, ideally keeping it in the same place in the frame.

It is an important skill and one that improves with a lot of practice. It allow multiple shots of the same moving target which increases the likelihood of getting your subject in the best positions.

There are a few ways to practice this skill. One of the simplest is to find a spot where you can take pictures of moving cars. Even better is to find a predictable spot for flying birds. Think about where you might find a lot of ducks or gulls and spend some time there.

VENEZUELAN TROUPIAL:
CANON 20D 100-400MM
F/5.6 1/800SEC ISO800

Feathering Focus

This a technique that can be very useful to "tighten up" your focus on a moving target. Even after you have attained focus, while you may not lose it and become unfocused, you can drift away from the best focus. Feathering the focus involves continuing to lightly refocus to maintain it as accurately as possible. It is especially useful when a bird is gradually flying toward you.

Practice, practice, practice
OK, I'm repeating myself.

IVORY-BILLED WOODCREEPER:
CANON 5D 100-400MM
F/5.6 1/640SEC ISO1000

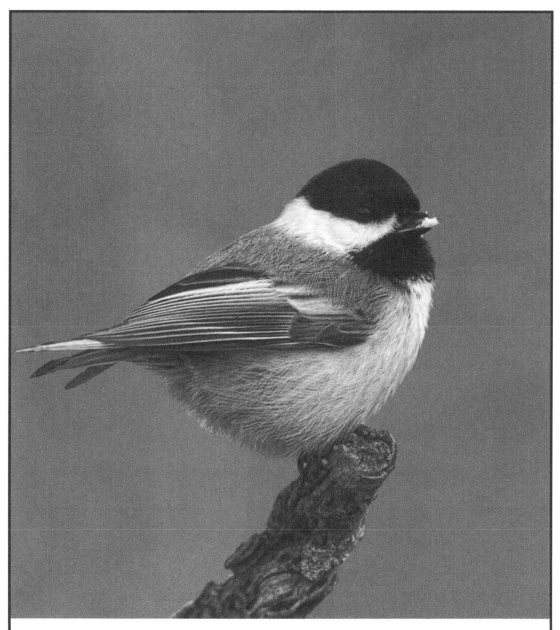

BLACK-CAPPED CHICKADEE:
CANON 20D 500MM
F/5.6 1/2000SEC ISO400

Where to find birds

AMERICAN TREE SPARROW:
CANON 5D 500MM+1.4X
F/6.3 1/3200SEC ISO400

Backyard Birds

Your own backyard is a great place to photograph birds especially if you have feeders that bring in a variety of species. Many birds that come to feeders often become tolerant of humans in the same area as long as they are not too close.

Many people who love birds set up a variety of feeders spread throughout their property. When you wish to photograph the birds, fewer feeders are better, as we wish to concentrate the birds in the area we choose. Ideally some birds will wait their turn at perches you have provided.

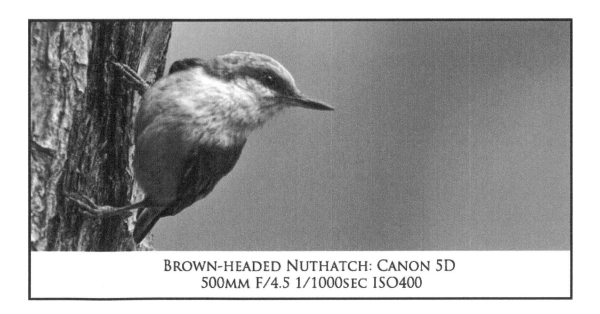

**BROWN-HEADED NUTHATCH: CANON 5D
500MM F/4.5 1/1000SEC ISO400**

Your first consideration in setting up your target feeder is lighting.

Once you decide from what angle you want to shoot from, set up your gear, sit in a comfortable chair and wait for birds to come to you. You need to keep them far enough away from buildings and trees so that they are not blocking the light. You need to keep in mind also that birds rarely like to feed where they don't have nearby cover as they are exposed to predators.

The direction of the light is also very important. You don't want to have it behind the subject, back lighting the bird. Most experienced photographers prefer the light at their back which ensures has no shadows and is evenly lit. Don't be dogmatic about it though as light that comes somewhat from the side can be excellent, especially if there is minimal glare.

After managing the lighting, you need to consider the background. Read the section on bokeh for what makes a great background.

Check our setups section for some ideas on how to make your feeder shots look more natural.

Captive Birds

Zoos and aviaries can be a good place to see and photograph unusual birds. Rescue and rehab centres may also be available, and they can put any payment or donation you make to good use.

Check with the organization about their policy on tripods. Even with a tripod, aviaries are often dark and you may need to increase the ISO.

For many photographers the goal is to make the image look as natural as possible. This means keeping man made items out of the image as much as possible. It is also easy to set up in spots where the light is favourable and there are no obstructions.

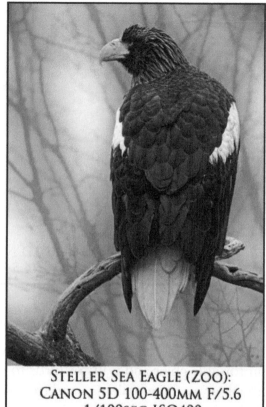

STELLER SEA EAGLE (ZOO):
CANON 5D 100-400MM F/5.6
1/100SEC ISO400

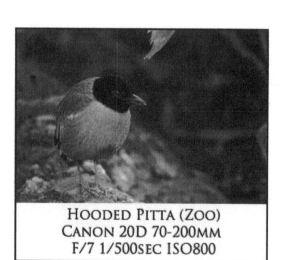

HOODED PITTA (ZOO)
CANON 20D 70-200MM
F/7 1/500SEC ISO800

You will find yourself fairly close to your subjects, so large telephotos should not be necessary. A 300mm lens or less is often ideal. Keep your shutter speed high, as quick movements are not unusual.

Have patience and you will often catch your subjects in an interesting or unusual pose.

Migration

The frenzy of spring migration and the more leisurely return in fall offers exceptional opportunities for a wide variety of bird species to photograph.

Migration offers birds in fresh breeding plumage while the return migration often shows non breeding plumages as well as juveniles.

A typical photographer's strategy during migration is to set up at one of the traditional hot spots and wait for the birds. You may have to endure large crowds but places like Point Pelee in Canada, High Island in Texas or North Ronaldsay in the Orkney Islands

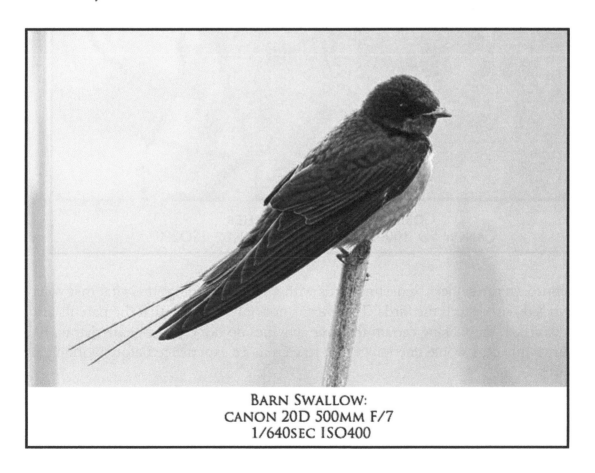

BARN SWALLOW:
CANON 20D 500MM F/7
1/640SEC ISO400

Breeding Birds

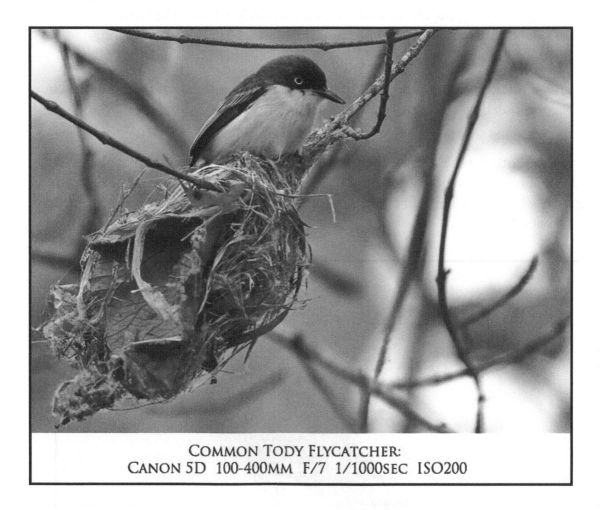

COMMON TODY FLYCATCHER:
CANON 5D 100-400MM F/7 1/1000SEC ISO200

We approach the subject of nesting birds with a strong warning. It is vital that your activities do no disturb the birds. This means not only ensuring that the parents are not disturbed, but making certain that our activities do not encourage predators. If you are a novice, I would encourage you to gain more experience before working in this area.

If the adults become agitated, move back or retreat altogether.

Avoid playing tapes or calls directed at the targeted species.

Do not move or disturb the nest, eggs or young in any way.

Don't alter vegetation to gain a better view. This will give predators a better view as well.

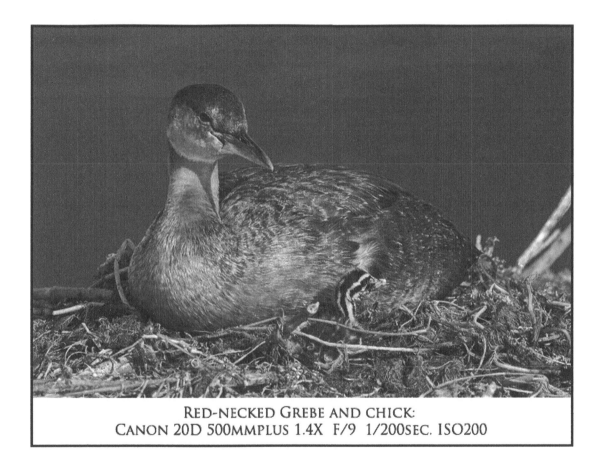

RED-NECKED GREBE AND CHICK:
CANON 20D 500MMPLUS 1.4X F/9 1/200SEC. ISO200

The first thing you need to do is research your subject. When is your target species expected to nest. There is a lot of variation in this. Some species like Gray Jays nest in late winter, usually in March. Many owls may breed early as well. Other species may nest later than usual. The American Goldfinch waits late into the summer when weed seeds become available.

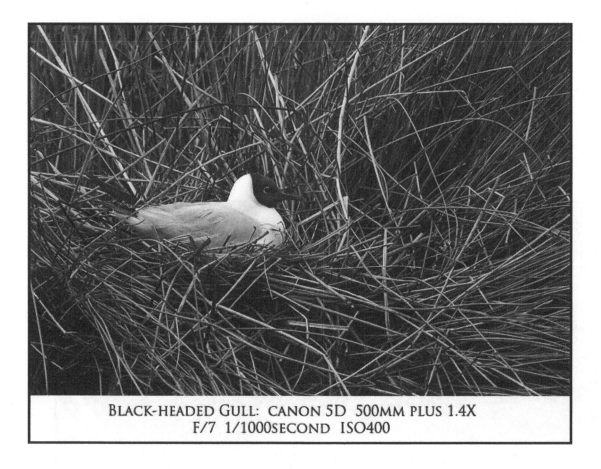

BLACK-HEADED GULL: CANON 5D 500MM PLUS 1.4X
F/7 1/1000SECOND ISO400

Once you know when they nest, it is easy to research where. The internet has made this easy. There are also some excellent books to guide you, see the list in our resources area.

You are in the right place at the right time and you need to locate the nest. A male bird giving its territorial song can help you locate the general area.

Now you need to watch for signs of nest building. depending on the species, the nest may be made of twigs, feathers, down from seeds or even spiderwebs. Watch for birds collecting and moving with these materials.

Locating the nesting site can be done by following the bird with your binoculars to minimize disturbance. Don't expect to find it right away, it usually takes time to gradually hone in on the exact site.

Approach the nest and set up your camera equipment slowly. The adults will likely flush. Retreat a distance and wait for their return. If they don't return within a couple of minutes, you should abandon the site as the adults are too skittish and will likely abandon the site if you continue. If they do return shortly, you can resume working yourself into position. Try to bring in all the equipment you need in a single trip to minimize stress to the birds. Don't forget water and snacks as well as a chair.

You will probably find obstructions to your view of the nest and you can temporarily tie them back. Use extreme care not to move the nest and always remove them when leaving.

It is usual for the noise of the shutter release to disturb the adults at first. After a short time, they will ignore the sound.

The situation we are discussing are birds that depend on cover for their breeding success. There are also species that depend on a nesting site which is inaccessible to predators, or who nest in colonies and depend on the power of numbers.

Don't neglect the fact that the singing male that helped you locate the nest is a worthy subject as well.

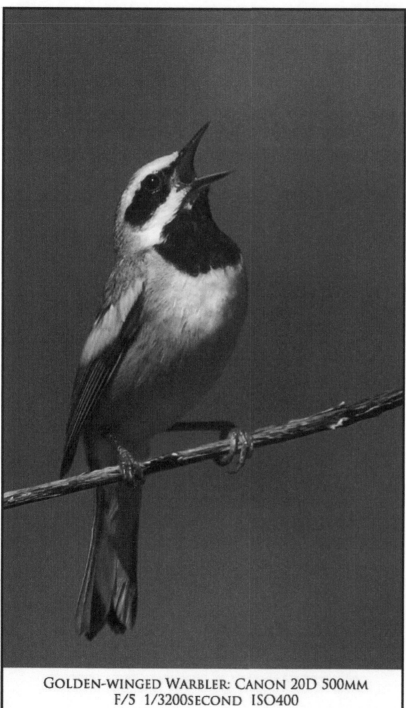

GOLDEN-WINGED WARBLER: CANON 20D 500MM
F/5 1/3200SECOND ISO400

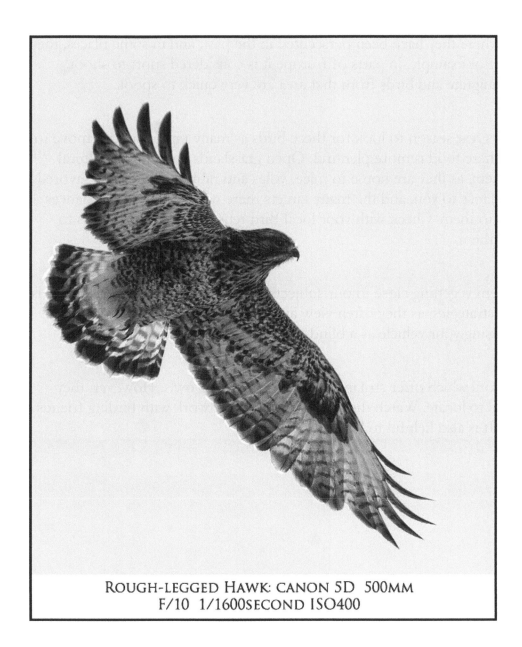

ROUGH-LEGGED HAWK: CANON 5D 500MM
F/10 1/1600SECOND ISO400

Raptors

Raptors, like hawks and eagles, are among the wariest group of birds. This is especially true where they have been persecuted in the past, and in some places, they continue to be. For example, in parts of Europe it is considered sport to shoot raptors as they migrate and birds from that area are very quick to spook.

Winter can be a great season to look for these birds as many raptor species move to favorite areas where food is more plentiful. Open grasslands and old agricultural fields are suit them, as they are home to mice, voles and rabbits. Find these favored wintering areas close to you, and the many targets there will multiply your chances of getting close to them. Check with your local Bird reports and other birders to help you locate them.

Our next problem is getting close to our subjects. using your car as a mobile blind is one of the best strategies, as they often view automobiles as non-threatening. Read the section on using your vehicle as a blind to optimize this technique.

A group of raptors which offer striking dynamic images are owls. However, they can be very hard to locate. Watch the bird reports and network with birding friends to locate them. It is also helpful to learn their calls.

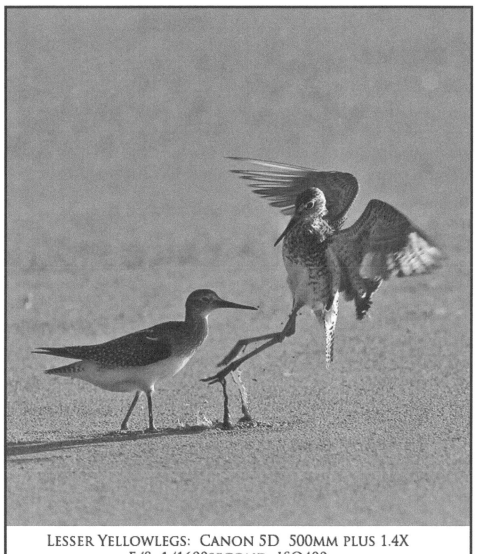

LESSER YELLOWLEGS: CANON 5D 500MM PLUS 1.4X
F/8 1/1600SECOND ISO400

Shorebirds

Shorebirds have a lot to offer to the nature photographer. Not only do they have beautiful plumage but they are active and can often be captured in images which show interesting behaviour.

The easiest time for finding these lovely birds is during migration. They are loyal to specific sites where they rest and feed. Do your research to find an area close to you. You also need to research the best time of year to expect to see migrant shorebirds. They are often moving outside of the times of high migration of other species. For example, many post breeding sandpipers may be returning as early as July.

Breeding birds make spectacular subjects but many species nest in remote tundra areas. However, for many nature photographers, a trip to a place like Alaska during this breeding period produces a host of wonderful images.

One of the secrets of making sandpiper images is having a low aspect. Get yourself and your camera low to the ground and you will see a dramatic improvement in the photos that result. Many of the best shorebird photographers can be found crawling on their hands and knees through the mud. This allows them to get close to their subjects, but also to get down to eye level with them to achieve the best results.

Seabirds

Seabirds provide some of the most exciting subjects for avian photography but quality photographs of these birds are not common. Many photographers consider them too difficult to obtain but a bit of knowledge and planning can give you outstanding and unique results.

Seabird trips go regularly from many areas. Have a look at our resources page for a list of trips available around the world. These trips can be very popular especially in the prime times, so book as early as possible. A good strategy is to book a couple of trips. Many participants prefer to have them spaced a few days apart to recover their energy as well as optimizing a variety of species.

Seabird trips normally mean handheld equipment and often, subjects in flight. Read up on our section of flight photography and get some practice before your trip. Not only will your subject be in flight, you and your equipment will be moving as well, and often quite roughly. These conditions mean that you need to keep your shutter speed a high as possible, 1/2000 of a second and higher might well be needed.

Due to these unusual conditions, your physical position becomes important. Keep your legs wide apart and and keep at least one handhold available. Since handholding your equipment with both hands is needed when actually taking photos, you may need to improvise to improve your stability. Finding a spot where you can lean your body against part of the boat or even hook one arm around can be very helpful for your photo success and personal safety.

The other aspect you need to consider is the possibility of motion sickness. There are few things as demoralizing as facing many hours at sea when you are feeling seasick. There are medications you can use such as the patch or anti-nausea medications such as Gravol. I take a Gravol tablet a few hours before setting out and apply half of a patch just before departure. The patch can have a great effect on some people, so use caution. I have seen some people who have become very drowsy to the point of not being able to function.

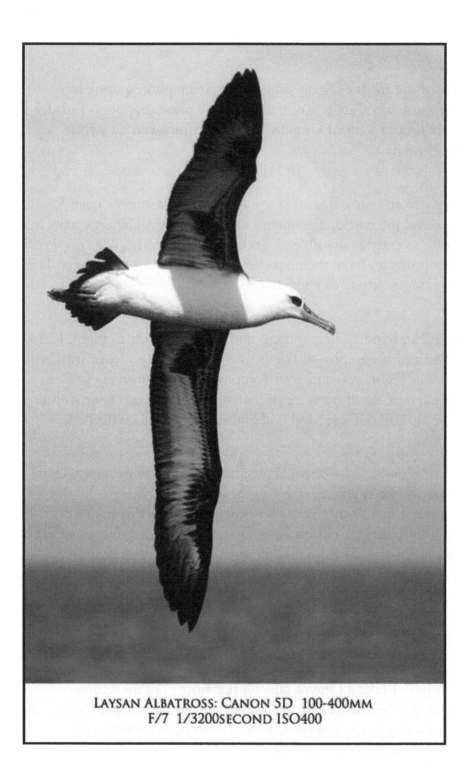

LAYSAN ALBATROSS: CANON 5D 100-400MM
F/7 1/3200SECOND ISO400

You can also watch what you eat to lessen the symptoms. Plain crackers are often useful to give some food in your stomach and to soak up excess stomach acid. Keep hydrated with many small sips of liquid. Try to stay out of the boat cabin and watch the horizon. If you are going to be sick, pick a spot near the back of the boat where the wind ensures you or your companions will be clear of blowback. Don't be discouraged, you are likely to have few problems, or be able to manage some minor ones.

Waterfowl

Waterfowl make great subjects, and beginners will especially find them productive. Not only are they large and easier to frame and focus on in comparison to other smaller groups of birds, but they are often found paired up or in large groups and offer a lot of interactive behaviour you can capture.

In many locations, waterfowl can be found in all seasons. In winter, visit traditional areas and you may find massive numbers. You can easily spend many productive hours capturing this activity. Watch for good setup spots where you can have suitable backgrounds and unobstructed views of birds flying in and out. You will also have opportunities to photograph feeding behaviour. If you want a real challenge, try capturing an image of a diving duck as it plunges!

In late winter and early spring, waterfowl begin to pair off and eventually leave for their breeding areas. Males start displaying to females and become very aggressive towards other males. Chases and fights are common. These moments can make very exciting image material. remember that this often involves very quick movements, use a high shutter speed like you do for flight shots.

As we get into spring, pairs leave their wintering areas and go to their nesting spots. They can be harder to find and more wary when you do, but persevere, you will be rewarded. Use your fieldcraft skills to make a quiet approach. Your subjects will be in fresh plumage and backgrounds can be excellent as new growth appears.

Even late summer and fall offers nice opportunities with waterfowl. Young birds are in various stages of growth and adults are going through interesting plumage changes.

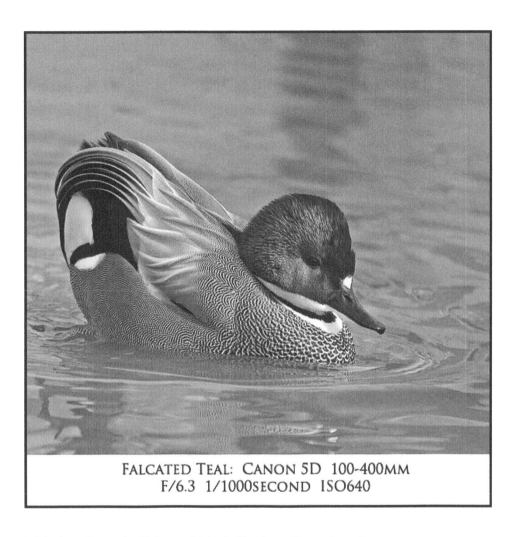

FALCATED TEAL: CANON 5D 100-400MM
F/6.3 1/1000SECOND ISO640

This lovely male Falcated Teal displays for a female.

Gulls

Gulls make excellent subjects, especially for flight images. They are large and relatively slow fliers and can often be found in abundance. While terns usually migrate to warmer climates in winter, gulls can usually be found in all seasons, even in the coldest weather.

Typical actions to look for include diving in water food, displays, bathing and breeding displays.

If you get the chance, spend some time observing and photographing a breeding colony. When pairs firsts arrive, they stake out their claim to a patch of ground and try to hold it against all comers. This involves plenty of aggressive behavior, including tugging of feathers and beak attacks.

Copulation, nest building and egg laying keep the colony and photographer busy for the nest few weeks. Finally the young arrive and provide a whole new dimension of photo opportunities

.

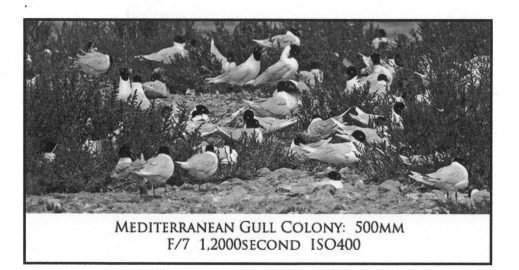

MEDITERRANEAN GULL COLONY: 500MM
F/7 1,2000SECOND ISO400

Pick the right time

One of the first rules you hear about bird photography is that it is best in early morning or to a lesser degree, late afternoon. This is true, not only do the birds tend to be most active then, but the light is usually better. You need to keep in mind though that there are exceptions.

For example, I once spent a lot of time looking for Short-eared Owls which were reported in a certain area with no success. This finally changed when I happened by just as the sun was setting and there were many owls out hunting. Some birds have their own schedule we will need to discover.

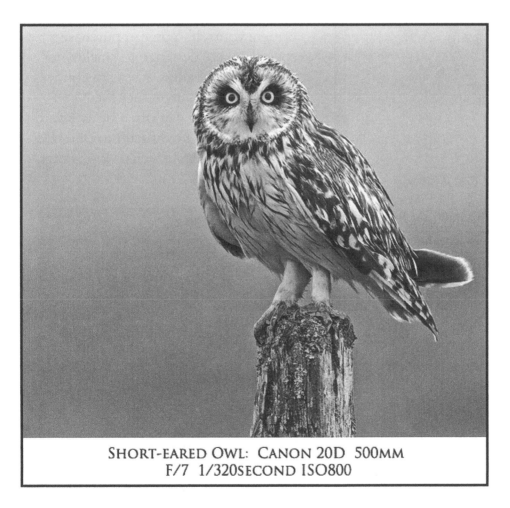

SHORT-EARED OWL: CANON 20D 500MM
F/7 1/320SECOND ISO800

Bad weather is good

PINE GROSBEAK:
CANON 5D 500MM F/6.3
1/100SECOND ISO800

Many photographers never go out when the weather is bad. Bad weather can be a gift to the bird photographer, one you should accept wholeheartedly. Rain and snow can add a dynamic element to images. You just need to be prepared for it. Dress warm and consider a finger-less glove for the hand you operate the shutter with.

Protection

The first consideration is to be sure your equipment doesn't become damaged. generally manufacturers will not repair damage to a camera body if they deem it to have been caused by water. This can be a very expensive repair.

Many DSLRs are advertised as being water resistant. This does not mean waterproof. You need to protect your camera yourself. You can purchase special covers designed to shield your equipment but allow access to controls. While they usually protect the equipment, they can often be awkward to use and may be difficult to find one which fits the largest lens. Costs range from about $70-$150.

BLUE-GRAY TANAGER:
CANON 5D2 100-400MM
F/5.6 1/80SECOND ISO400

If you are not heading into a monsoon, you can look at DIY measures. Often something as simple as wrapping clinging plastic wrap around the join where the lens and camera body connect will increase your protection. Seabird photographers who encounter salty sea spray usually make their protection with plastic bags and tape, fashioned in a manner that gives them access to their camera controls.

An alternative is to set up in a sheltered spot like your car or a roofed area. See our section on using your car as a blind for further information.

Even if you are confident that your camera body is 100% waterproof, you need to protect the front lens element. One misplaced drop of rain will ruin the resultant images. Usually the lens hood which comes with the lens is sufficient.

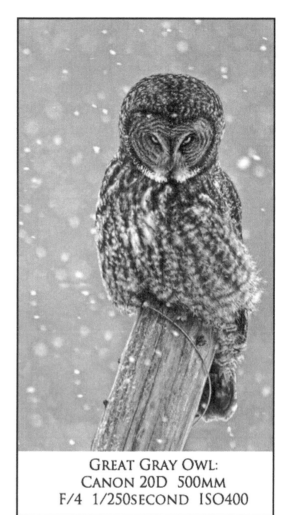

GREAT GRAY OWL:
CANON 20D 500MM
F/4 1/250SECOND ISO400

CANADA GEESE:
CANON 5D 500MM F/13
1/160SECOND ISO800

Rain

Rain not only adds a dimension to an image, it often makes your subject more approachable. A bird who has settled onto a perch to wait out a storm is often loath to leave, and can be approached much easier.

When shooting in a driving rain, consider the angle of the rain, and incorporate that as part of your composition. When they are sitting, they often fluff out their feathers to create air pockets which helps them conserve heat. Be ready for these moments which prove unique images.

RED-TAILED HAWK:
CANON 20D 500MM
F/5 1/800SECOND ISO400

Snow

Snow has unique qualities in an image, it sets a tone and dimension not found in other images. The viewer has a better understanding of a creature that copes with these conditions.

Snow also provides something singular. Big fluffy flakes of falling snow reflect the light, providing a more even distribution of exposure on your subject. This is especially apparent to larger subjects like hawks and owls.

There is also another bonus in the cold weather associated with snow and that is that many raptor species are more approachable. On a very cold day you will find that birds will be easy to spook. I believe this is because they are less willing to use up their energy reserves in unnecessary flight.

Wind

Wind can be the exception. Although it may provide something to an image, it generally makes shooting more difficult. High winds can increase equipment vibration causing images to lose sharpness. Consider increasing your shutter speeds in these conditions.

Many photographers have also experienced the sickening sound of their equipment hitting the ground as tripod and camera is blown over. In high wind conditions, always keep one hand on your equipment.

Frost

In perching all night in a still position, birds may experience frost coating their plumage. While this is uncommon, if you get out early on a regular basis, you may well see it and capture some unique images.

GREAT GRAY OWL: CANON 20D 500MM
F/5.6 1/1000SECONDS ISO200

You appreciate the conditions birds have to endure when you see the frost covering this Great Gray Owl

Fieldcraft

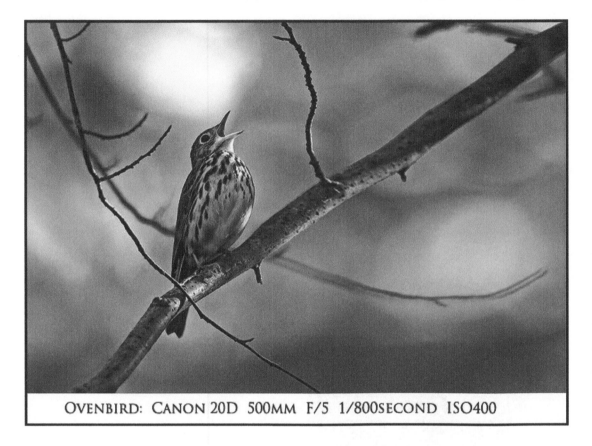

OVENBIRD: CANON 20D 500MM F/5 1/800SECOND ISO400

This image is a good example of what can be obtained through judicious use of a recording. In spring, the Carolina Woodlands ring to the "teacher, teacher" call of this warbler, but they are not easy to get close views of.

I had played a single short playback of their call in suitable territory and was quickly rewarded with a close appearance by this territorial male.

Using Recordings and other sounds

Using recordings of bird calls can be very effective but also controversial.

During breeding season, male birds will make a call distinctive to its species at various parts of the territory it has claimed. When it hears another male's call in the same area, it will aggressively move to challenge the intruder.

Playing a bird's breeding call may often provoke a quick appearance of the male. Often other species may come to see what the excitement is about. It is important that this be done conservatively, not more than 2-3 times spaced well apart. Remember also that some places ban the use of recordings entirely, check on their policy.

It is important to use recordings as part of an overall plan. Learn where your target will be and get to know its habits.

Keep the volume low, there is a tendency to think the louder the sound, the more it will attract the subject but it will only respond if it sounds natural.

Besides using the bird's call, many birders become adept at "phishing". This involves making a small repetitive noise with the lips. Theories about why birds react range. Some consider that the sound of scolding or alarm call birds make when they see intruders and small birds often join to mob these predators. Others think the sound may resemble insect noise and be regarded as a source of prey. personally I think birds are just naturally curious and will investigate the unknown. Regardless of the reason, many small birds do respond to phishing.

Some birders have become skilled at making calls like the Screech-Owls which can result in a mob of furious responders.

Using Blinds or Hides

One of the effective tools for the bird photographer is the use of a blind and yet it is one many neglect to use. In fact one problem that you can experience with a blind is that the birds come too close and the lens you are using will not focus on it.

Stationary Blinds

Stationary blinds are generally only useful for birds who are on breeding territories, displaying areas known as leks or those that are being baited. These situations hold implications which we deal with on the section on ethics.

Setting up a blind in a breeding birds territory often means taking photographs at or near the nest site. The first consideration is whether it can be done without disturbing the birds. No photograph is worth having the parents abandoning eggs or nestlings due to your presence. It is also very important that predators are not alerted to the location of the nest due to your activities.

Your choice of where to set up the blind allows you to minimize the obstructions in your way. If you are photographing at a nest site, you need to be high enough so that the edges of the nest don't conceal the contents. Never "groom" a site by removing branches and twigs. These are what hides the nest from predators. With a telephoto lens, there is no need to get up close. The farther away you set up, the less you will disturb your subjects and the more success you will have.

The blind itself can be improvised from simple materials. Posts covered with canvas or camouflage netting works fine, and you can often use existing shrubs and branches as the supports. There are commercial blinds available, meant to be light and easy to transport, and to be erected and dismantled quickly and easily.

When setting up a blind, consider your comfort and safety, You may be enclosed for hours. Consider the necessity of being able to move around to reach a new shooting position or relieve cramped muscles.

You will also need to include some basic things other than camera equipment. Water is a priority. A blind is an enclosed area which can become very hot and you need to guard against dehydration. Other considerations are high energy snacks, a cloth to wipe away perspiration and additional clothing if there is a possibility of a chill.

If you have set up a non-commercial blind, you want to leave it for a few days, so that the birds get used to it being there. With commercial blinds, you run the risk of theft by leaving it, so you need to assess the situation.

Getting into the blind usually means going in before dawn. You may find that you can also go in when your targets may see you and waiting till they are used to the fact. Birds may know that you went into the blind but resume there normal activities. The blind can act to reduce further disturbances even when your subjects are aware you are there.

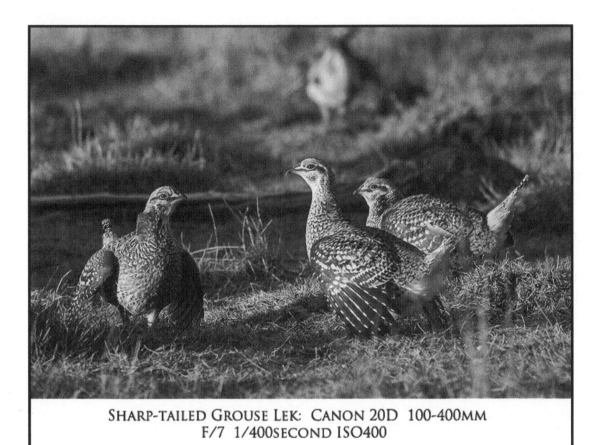

SHARP-TAILED GROUSE LEK: CANON 20D 100-400MM
F/7 1/400SECOND ISO400

Male Grouse display in a Lek on Manitoulin Island. A large stationary blind had been set up nearby using poles and burlap. We had to enter well before sunrise as the birds dance very early in the pre-dawn and then disperse in early morning. About 20 males were involved while the occasional female could be seen at the edges observing.

The Mobile Blind

Your car can be an excellent part of your equipment, not only allowing you to move about the area picking up targets, but providing cover as well. Of course, birds see your vehicle but they have grown used to cars and don't see them as threats as long as you remain inside. Sudden stops will spook them, so you need to develop the skill to slowly approach, and to get closer as they look away. It can take experience but you can become quite adept at it. It is especially helpful to have little or no other traffic in the area you are photographing in.

The first problem you need to sort out when photographing from your car is how to keep your heavy camera and lens still. My usual solution is the simplest and that is to rest the front of the lens on the side window sill. I can quickly and easily raise and lower the window to get the ideal height for a particular subject and it gives me a great deal of freedom of movement. Additionally when using a 500mm lens, I take off the large lens hood which makes the setup much less cumbersome. The downside of working like this is that it is rough on your equipment. The paint on the barrel of your lens is soon scratched and worn and the front element of your lens is vulnerable without the lens hood.

Bean bag

The bean bag method uses a bean bag which rests on the window sill and has sufficient volume to cradle the barrel of the lens. It is a simple arrangement but surprisingly effective.

Window mount.

A window mount is designed to connect equipment to give a stable platform for your camera. It can be a very solid. It doesn't have the flexibility for quickly moving your car to another place although a quick release on the mount helps.

See our resources section for more information on window mounts.

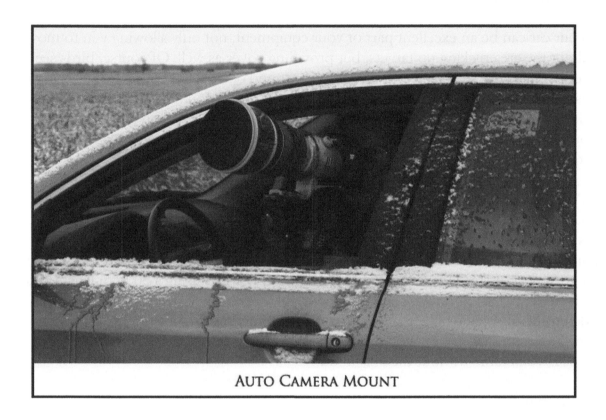

AUTO CAMERA MOUNT

Tripod

There are a number of ways you can use your regular tripod in the car, usually involving one tripod leg between the driver seat and door, and the other two from the drivers side across to the passenger seat. In my opinion, this seems cumbersome but some people have success with it.

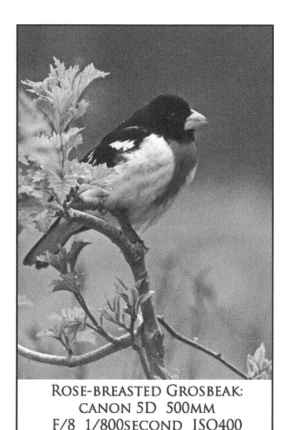

ROSE-BREASTED GROSBEAK:
CANON 5D 500MM
F/8 1/800SECOND ISO400

Setups for photography

You can turn your yard into a studio by strategically placing natural items where they can be used by birds. The idea is to place sticks, logs and other items near to food and water sources. As an extension, you can also control the backgrounds to improve the final results.

Perches should be local materials and dark ones cause less problems in exposures. Place them close to feeders and water supplies and birds will use them going to and from these resources. Try to use small feeders and containers for water. If there is too much room, birds will have no reason to wait their turn on your perch.

A particular bird will usually return to the same spot repeatedly. You can get a tight focus on this spot and be prepared for its return.

Your equipment setup point is critical.

1. Take your images from a blind or hide. Check with hunting stores for inexpensive choices. Use a long lens, 400mm or greater if you have one. This should give you enough distance not to scare off your targets.

2. Make sure the line of sight to your perches is unobstructed.

3. Ensure your backgrounds are good. If need be you can place an artificial background behind the perch. A square of particle board pained a neutral color can be setup behind and will look surprisingly natural.

Attracting birds

Providing food is, of course, a primary method of attracting birds but there are others which are useful.

Water is often overlooked as a means of getting bird traffic, but it can be great for luring birds. This is especially true in winter when water sources may be difficult to find. To prevent freezing, look for a warmer that keeps it open. Often they can be purchased at the same place where you get seed supplies.

You can often attract breeding birds to nest in your yard. Think about what you can provide for actual nesting boxes. Consider also about nesting materials. leave the dead stalks of flowers in your garden, as you'll find that birds love to pull them out for you. other materials like feathers can be a real magnet. Not only will you have opportunities to photograph this nest building activity, but hopefully you it will result in young birds, which are always a treat for the eye and camera.

A very simple setup in the arid conditions of South Texas attracted a Cactus Wren and this lovely Altamira Oriole.

ALTAMIRA ORIOLE:
CANON 20D 500MM
F/8 1/1000SECOND ISO400

CACTUS WREN:
CANON 20D 500MM
F/7 1/800SECOND ISO400

Remote Photography

MOURNING DOVE: CANON 5D 100-400MM F/7
1/2000SECOND ISO400 FLASH

Remote Photography

Remote photography refers to situations where the photographer does not handle the equipment directly. With Wi-Fi and Tethered Controllers, the shutter and other controls are operated from a distance. Photo traps refer to setups where the image is taken by the movement of the subject tripping the release.

Wi-Fi and Tethered Controllers

Many owners are not aware that their cameras may have remote control capabilities. If your camera has a built-in infrared receiver you can build or buy a remote to click the shutter from afar. Smartphones and tablets often have the ability to remotely control camera and they make excellent controllers. Canon bodies in particular are usually controllable in this manner.

The advantage to this type of control is, of course, you have less concerns about spooking your subject. The downside is that you have little control in framing and composition

Photo Traps

A photo trap setup involves an infrared beam which triggers the shutter when it is joined or interrupted. I have heard the complaint that this type of photography removes the creative element from the photographer and there is some truth to that. On the other hand the problems that need to be solved to obtain interesting images can be very stimulating.

I had envisioned an image of a Mourning Dove, wings and tail feathers spread when I setup up a phototrap near one of my feeders. I left only one side of the feeder open in order to funnel the subjects to the desired position.

Check our resources section for more information.

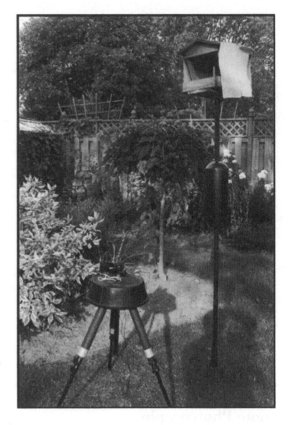

In flight

AMERICAN KESTREL: CANON 20D 500MM
F/6.3 1/1000SECOND ISO200

The primary distinguishing feature of birds is their ability to fly and for many photographers, capturing these moments is their primary goal.

Good Equipment

While high priced is not a requirement for most bird photography, it is an asset for photographing birds in flight. Quality lens will focus faster than less expensive one and professional camera bodies have a quicker and more accurate auto-focus. Don't be discouraged if you don't have high end equipment, you can still make excellent images although your success rate will be lower.

Fast shutter speed

It is not a surprise that birds in flight require high shutter speeds. The faster your target is moving its wings, as well as moving against a background, the faster your shutter speed needs to be. The actual shutter speed required will vary with each situation but ranges of 1/1000-1/4000 sec are common.

Depth of Field

In our quest for fast shutter speeds, it is common to move the f-stop as high as possible, perhaps around f/4. In birds which are large or close, this may be too narrow a depth of field and we may find portions of our target such as the wing tips, out of focus. examine your results with a critical eye and you will gradually find the correct settings becoming second nature.

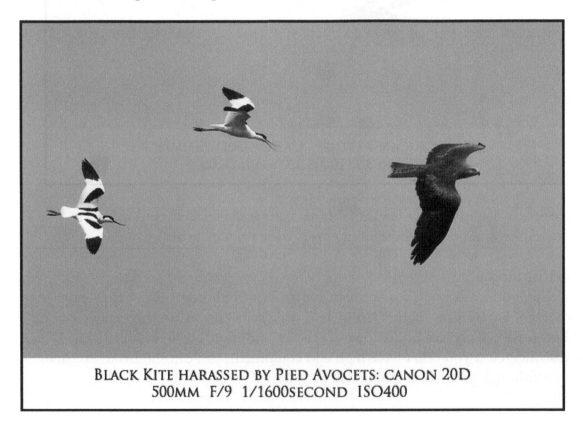

BLACK KITE HARASSED BY PIED AVOCETS: CANON 20D
500MM F/9 1/1600SECOND ISO400

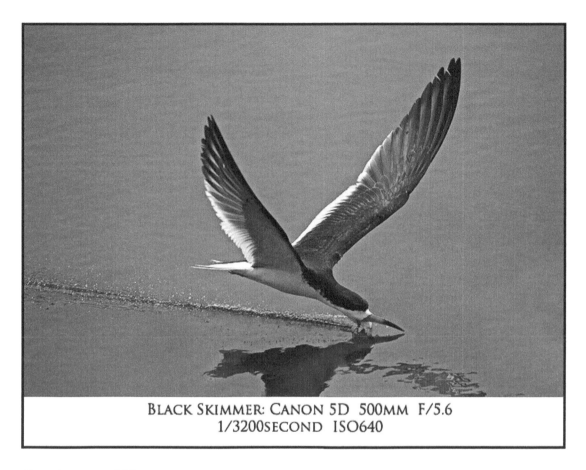

BLACK SKIMMER: CANON 5D 500MM F/5.6
1/3200SECOND ISO640

Continuous AF

Choose the continuous autofocus setting on your camera. Canon calls this mode
AI Servo AF while Nikon calls it Continuous-servo AF. In this focusing mode the
camera will continuously adjust the focus of the lens while light pressure is
maintained on the shutter release. The idea is to lock focus on your target and let
the camera adjust focus as the target moves by continuing to depress the shutter
half way.

Feathering focus

Feathering the focus is a special technique that can increase the sharpness of your images. Although Continuous AF mode will automatically adjust your focus as your target is tracked, it is usually sharpened when first acquired. Feathering focus involves reacquiring the focus manually as the target is tracked. This involves keeping your target tracked on your active sensor and gently lifting your finger and pressing half way again to regain focus. This can be repeated, interspersed with shutter bursts. This is a technique which becomes easy with a lot of practice.

AF Sensor selection

Their is a multiple array of focus sensors and you can change the settings to choose which are active. Many photographer leave only the center sensor active when photographing birds in flight since they want to hone in on a single portion of the frame. A small number of photographers feel that having all the sensors active is more effective and you may want to experiment with this.

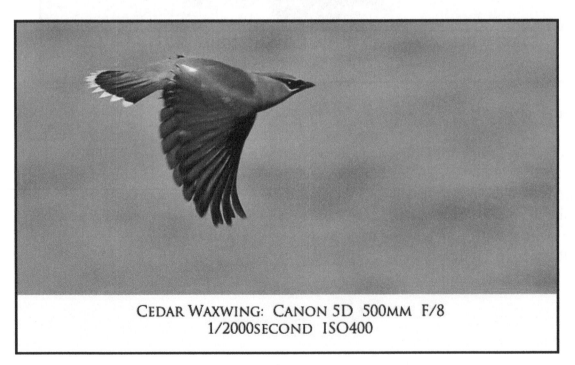

CEDAR WAXWING: CANON 5D 500MM F/8
1/2000SECOND ISO400

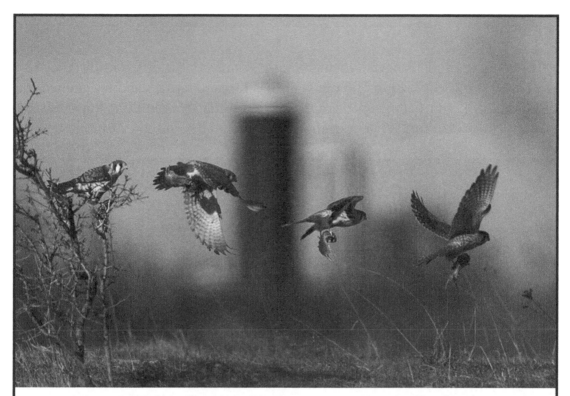

AMERICAN KESTREL (COMPOSITE OF CONTINOUS BURST: CANON 5D 500MM PLUS 1.4X F/5.6 1/1600SECOND ISO400

Continuous Burst

Your DSLR can be set for single shot or Continuous Burst. Set it for Continuous Burst and take a series of bursts as you pan with your target. With practice, you will recognize the best times for these bursts and the result will be a many images of your target in a variety of wing and body positions. Good wing positions are often when the wings are fully extended above or below the body. Not only does the wing plumage show to advantage, but they are less likely to hide the bird's head. It can be almost impossible to time a single shot of this wing position and a burst of multiple images helps to ensure it.

Lens limiting

Many super telephoto lens have a focus limiting switch set for different distance ranges. For example the Canon 500mm f/4L has three ranges it can be switched to: 4.5m to infinity, 4.5m to 10m, and 10m to infinity. Where present it is important to set the lens at the expected range to minimize the time the lens takes to focus.

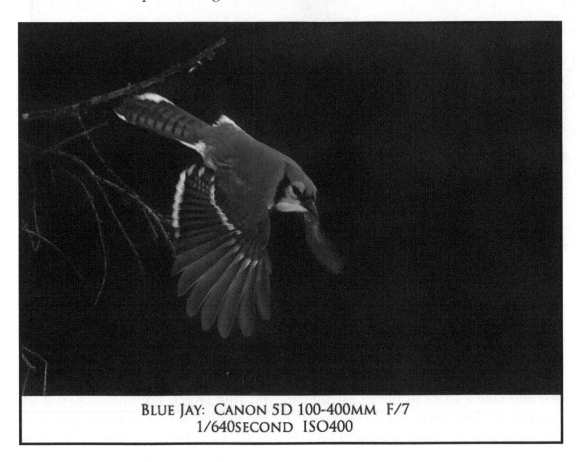

BLUE JAY: CANON 5D 100-400MM F/7
1/640SECOND ISO400

Pre-focus

If your subject is moving on a predictable path it can be very useful to pre-focus on that spot and pick up the subject as it enters that area. Birds often form definitive habits and, if you watch for them, you will be surprised to find how often you can use it to your advantage. For example, I once noted a number of swifts hawking for

insects who would swoop up along a sea-cliff and dive back down after reaching the top. Swifts are notoriously fast and erratic fliers but this repeated pattern allowed me to pre-focus and obtain some images of them.

Handholding

While a tripod is generally recommended for static bird photography, handheld is often better for birds in flight. With a tripod it can be awkward to smoothly follow the flight path of your target. Using a monopod is only marginally better.

In order to successfully photograph birds by handholding the camera, it is important to do so in a manner that is not too fatiguing, yet maximizes your chances of good results. With one hand on the camera body and shutter, hold the lens from underneath as far towards the front as is reasonable comfortable. When you look through the viewfinder, press your face slightly into the back of the camera. This will provide three points of contact. As you would expect, keep your legs comfortably apart.

Breath control is another important aspect of flight photography. As you follow your target, breath in a slow and regular manner, and hold your breath just before releasing the shutter.

Acquiring your target

When you first start trying to photograph birds in flight, it can be surprisingly difficult. The good news is that it becomes second nature with practice.

The simple method is to have your telephoto lens at maximum zoom and as you watch the bird in flight, bring the viewfinder to your eye and continue to follow its path. If you are finding this difficult, reduce the zoom and practice until you are successful, then start increasing the zoom.

Some photographers acquire the bird at minimum zoom and zoom in as they follow it through the viewfinder. I find this unnecessary complicated but you may find it useful.

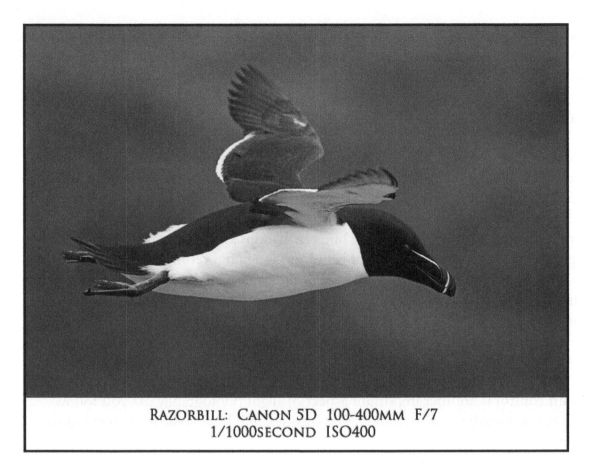

RAZORBILL: CANON 5D 100-400MM F/7
1/1000SECOND ISO400

Tripod

A Super Telephoto Lens and camera Body can be heavy and many photographers prefer to use a tripod. If you use a tripod make sure you use a Gimbal head which will allow you to make easy movements in both the vertical and horizontal. You may also need to loosen the collar around the lens which attaches to the head so that you can rotate the lens to keep it level.

For equipment safety I would recommend that you form the habit of periodically checking to make sure your head attachments are tight.

Purposed blur

There are a lot of creative photographs that have been produced which intentionally include motion blur of the subject. If done well, they can convey a great sense of movement. One of the nicest effects is matching the speed of the bird by panning but letting a slow shutter speed blur the wings. Another great effect is having a non-blurred background and enough motion blur of the subject to show movement but still leaving it recognizable. Experiment and have fun with it.

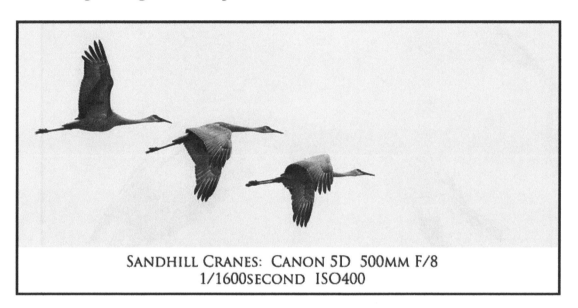

SANDHILL CRANES: CANON 5D 500MM F/8
1/1600SECOND ISO400

Lighting and flash

Due to the distance usually involved, flash is often not useful. This means you need to rely on natural light. On cloudless days this can be a problem as the differences in lighting between the top of the bird and its underside can be too great a range of exposure for most cameras. The top tends to be overexposed and the underside underexposed. You can still solve the cloudless problem by shooting in early morning or towards sunset, when the rays of the sun don't come from overhead. Even when it is overhead, you can catch your target when it is banking and its underside is exposed to the sun's rays.

Of course, cloudy days are much better and most cameras will easily handle the range of exposure presented.

If you run into a particularly difficult exposure situation, you can use the Exposure Bracketing function to your camera allowing a series of varied exposures. For example a bracketing setting of -2/3,0/=2/3 can provide an excellent range.

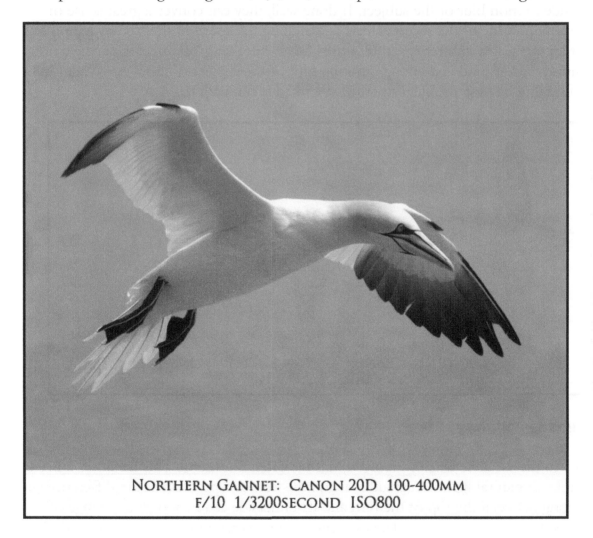

NORTHERN GANNET: CANON 20D 100-400MM
F/10 1/3200SECOND ISO800

Practice exercises

Learning panning skills, settings and many other aspects of flight photography are things you need to practice to become skillful in.

One of the practice exercises often recommended for the beginner is to photograph moving cars. You goal is to practice panning the moving cars with your desired result being an image of an auto that isn't blurred against a blurred background. You can examine the results and consider how successful your settings are and what adjustments you should make. You will also learn what physical stance is both comfortable and successful.

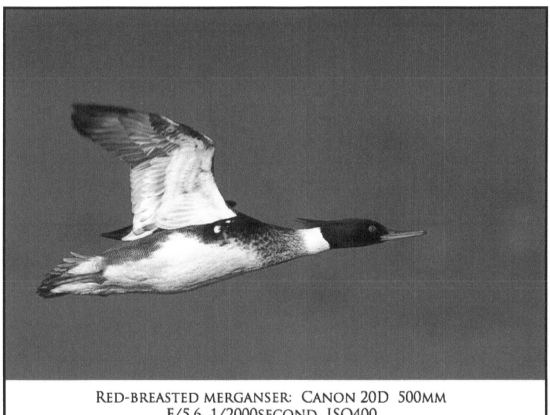

RED-BREASTED MERGANSER: CANON 20D 500MM
F/5.6 1/2000SECOND ISO400

However, automobiles have a predictable path. A better method of training your skills is with large species who can be found in numbers. good subjects are waterfowl, especially in winter where they tend to congregate in large groups, gulls and cormorants. Ducks make great subjects as they can be found in winter numbers when other birds are scarce and they have beautiful plumage which results in great images.

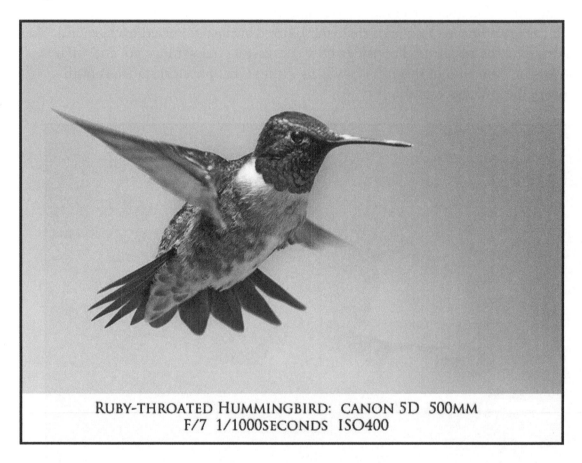

RUBY-THROATED HUMMINGBIRD: CANON 5D 500MM
F/7 1/1000SECONDS ISO400

When you have located a good area for large birds, your first step should be to observe. You will probably start to observe patterns which will allow you to set up in a spot that is ideal for sun location, lines of sight and cover.

Analyze your results. Its terrific if you have some great images but you will learn more from those that are less worthy. What is wrong with them? What can you do to make them better?

Panning

Panning involves moving the camera in a horizontal plane and it is a primary skill required for the photography of birds. Since bird flight doesn't always stay level with the camera, it actually often involves some changes in the vertical plane which is referred to as tilting.
Special action situations.

Takeoff and landing

One of the best and easiest methods of photographing birds in flight is just as it takes flight or comes in to land. Small fast flying birds like Kestrels can be very difficult to photograph in flight, especially when you consider they are usually very wary. Often they can be approached carefully when they are perching, and then focused on. When they take off, a short burst may be possible. Using your car as a blind is useful with this technique.

Diving

Birds that eat fish like Terns, Gannets, Auks and Pelicans make great subjects as they dive for food. They usually stay in the same area when there are fish to catch, and this allows the photographer to hone in to critical moments.

Flying with prey

Birds which breed in colonies offer exceptional opportunities for great images as they carry food back for their chicks. Check if their are accessible breeding colonies near you. Think about species of Auks, Gannets, Herons, Cormorants, Gulls and Terns. Of course, you need to take extreme care not to disturb the birds.

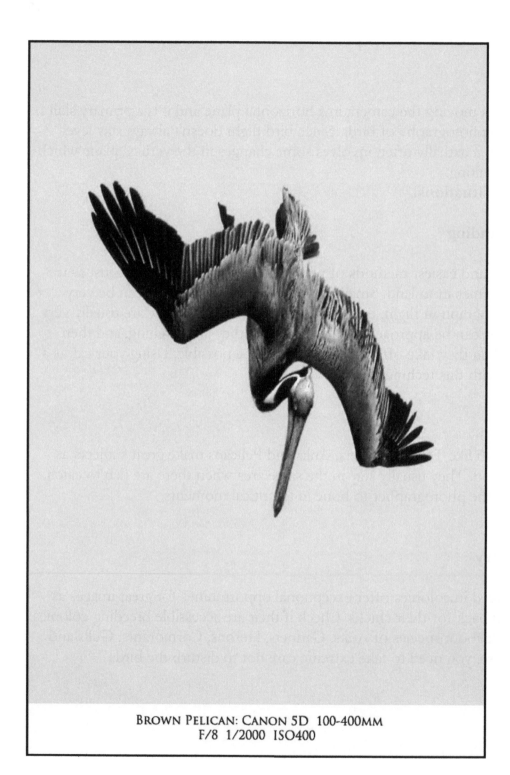

BROWN PELICAN: CANON 5D 100-400MM
F/8 1/2000 ISO400

Working Your Subject

Once in a while we come upon a situation where a subject is very interesting and cooperative, where the light is great and other conditions are excellent. Take advantage of it. Don't take a few images and move on. Explore your subject. Get close up portraits. Take horizontal and vertical images. Go wider and show its habitat. Catch interesting behavior.

An exception to this guideline might be birds who roost during the day like owl species. You don't want to keep them awake when they need to be sleeping. You are likely to get a series of images without a lot of variation anyway. And nobody likes a cranky owl.

The images that follow are all of the same bird, a juvenile Red-tailed Hawk hunting along a fence line. It was completely unconcerned with my presence . I was able to slowly move with it and photograph from my car, and was rewarded with dozens of varied images.

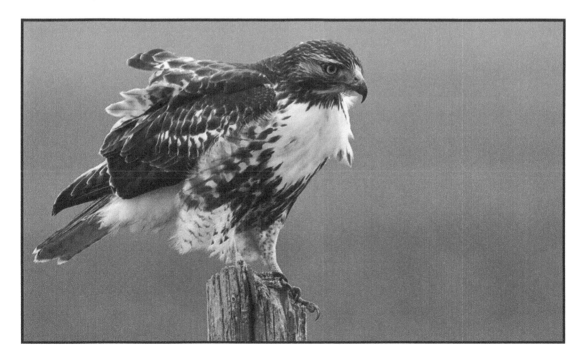

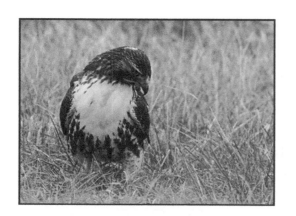

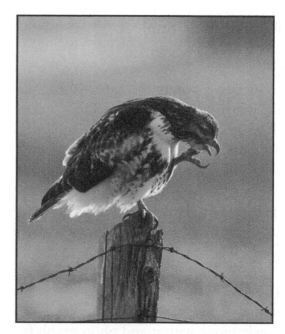

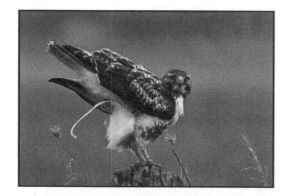

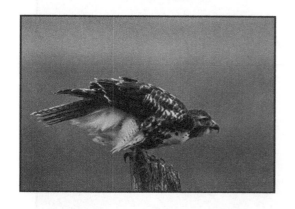

Composition

You can become skilled with your camera and learn the secrets of fieldcraft but what defines your style and uniqueness is your ability to compose an image. Following are some general guidelines to composition.

Don't center the subject

Many times composition in bird photography deals with the placement of the subject. It is rare that a subject looks best centered in the frame, and in fact tends to be a sign of a beginner.

Move the subject off to one side, either when shooting or by cropping when processing the image.

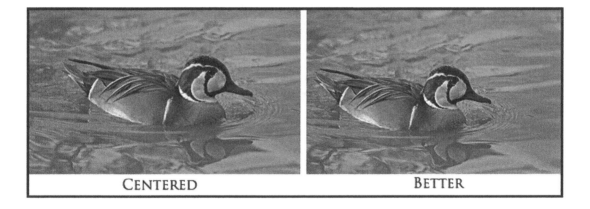

CENTERED BETTER

Look into space

You can choose on which side to pace a greater amount of space based on the direction the bird is looking. It is better to have the bird looking into the larger space. A viewer will feel the subject as being cramped or constrained if it is looking into the smaller area.

LEAST BITTERN: CANON 5D 500MM F/11 1/800SEC. ISO400

Rule of thirds

When an image is divided into a 3 by 3 grid, it is found that a composition becomes pleasing to the viewer when major elements of the image are aligned along the lines and intersections of the grid. It has been proposed that this is due to a natural energy or tension which makes the image more dynamic.

Not only does this guideline discourage placing the subject in the center but it goes against splitting the image evenly on the horizontal as well

In the image of an Acorn Woodpecker which follows, the vertical shape of the woodpeckers body and the horizontal branch both line up roughly with these grid lines. Additionally the birds eye is near the intersection of two lines as is the intersection of the bird and its perch.

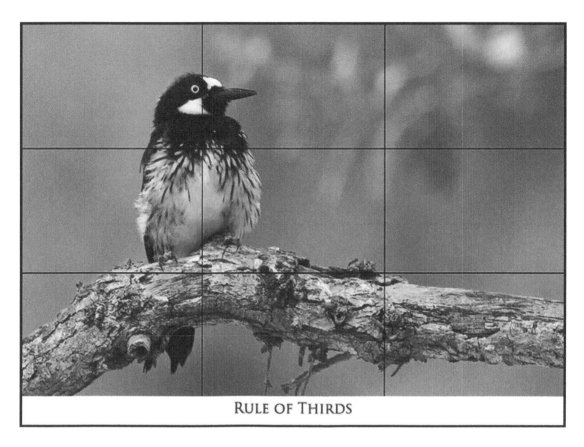

RULE OF THIRDS

Size of subject in frame

Unless the surrounding habitat adds to the story your image is telling, you want to have the subject large in the frame, but not too large that it gives a confined look to your subject..

Portrait or landscape

Often the general shape the bird presents dictates the orientation we may use for the image. Tall birds prefer head room. If you have a bird that is much taller than it is wide, it will usually look better in a portrait format.

Don't clip body parts even if they are not seen.

Clipping feet is most often the problem here. A birds legs may be submerged in water but the image viewer will subconsciously know they are there and will feel something is wrong if they are clipped.

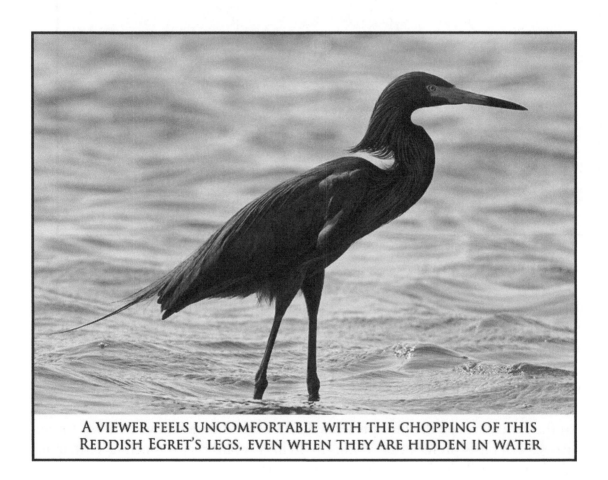

A VIEWER FEELS UNCOMFORTABLE WITH THE CHOPPING OF THIS
REDDISH EGRET'S LEGS, EVEN WHEN THEY ARE HIDDEN IN WATER

Break the Guidelines

Don't blindly follow these guidelines, sometimes you need to ignore them.

The simple story of the Gull below is its landing on the water but the splashes need to be included to tell that tale and more space is needed behind the bird.

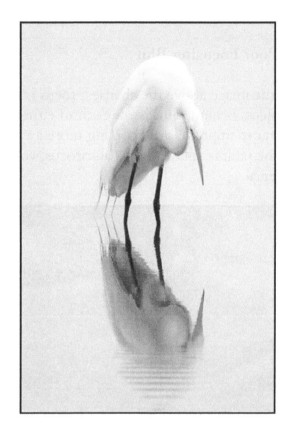

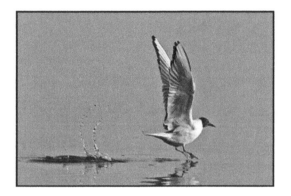

Another situation where you need to go against the guideline is where the subject is symmetrical or perhaps needs to be shown in a portrait mode to include its reflection. Simply following the guidelines against centering the subject may give a completed image which looks awkward.

The image of the Gray Heron might be too small in the frame according to guidelines but the marsh with flowers makes the story more interesting.

Causes of Poor Images

1. Poor Focusing Blur

In the image above the sharpest focus is on the foreground grass rather than subjects behind. This is the fault of either you or the auto focus of your camera. You can improve by becoming more aware and meticulous in your point of focus. If the fault is your cameras autofocus, you may have better results by switching to manual.

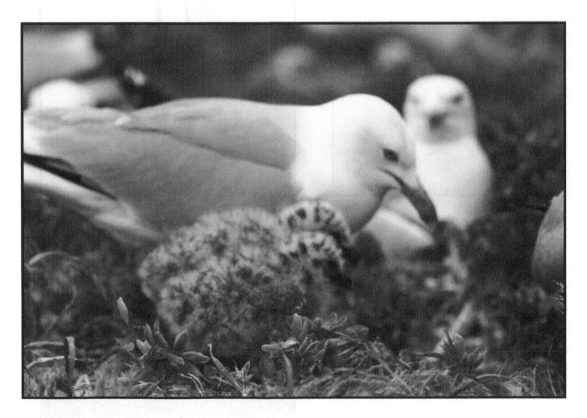

2. Camera Shake Blur

Looking at the image below, you will see areas were there is a ghost or duplicate. This is typical of camera shake, the shutter speed was not sufficient to freeze the motion caused by hand holding the camera while shooting.

One of the easiest solutions is to use a tripod. You can also change the settings to increase the shutter speed by increasing the ISO or decreasing the Depth of Field or f-stop.

Another good practice is to learn how to hand hold shoot with a minimum of shake. Lock the elbow of the hand holding the camera against the body, keep your legs spread and press the shutter very softly.

3. Subject motion blur

The back wing of this female Red-winged Blackbird is blurred because I didn't have a fast enough shutter speed. The common "solution" to this situation is to say that you meant to do it, to show a sense of motion. Baloney!! While there are occasions when a blur looks great, most of the time an image looks much better without it.

This usually happens when you are shooting a relatively still subject who suddenly moves. Since these movements properly captured can be some of the best, especially for nature photographers, you need to anticipate them to get them. This means set your camera to a much faster speed than is needed with your still subject, and you will be ready for that action shot.

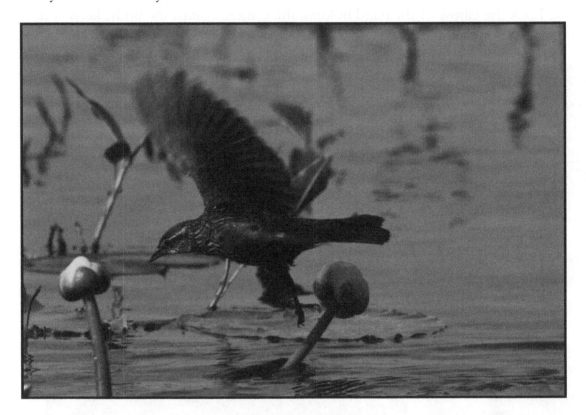

4. Too much Contrast

Although greatly improved in the last few years, cameras can only handle so much Dynamic Range, that range of exposure from the darkest to the lightest. This commonly happens on bright days when the areas in shadow lose detail or become "blocked".

The solution has been to avoid shooting in these conditions or to expose for that part of the image that is important.

5. Lens Flare

Lens flare occurs when light entering the lens bounces off of the various elements. Sometimes creative photographers use it for effect but often it is an unwanted addition.

It is caused when the sun or other bright light shines down the barrel of the lens. As well as watching where you are shooting, you can also give yourself more leeway by using a lens hood.

An unwanted lens flare can often not be fixed in processing. If it is minor, you can increase the image contrast to regain what was washed out, and you can attempt to clone out stronger portions.

In the interest of full disclosure, the following image has had the flare added in Photoshop. Apparently I am incapable of making this error and have no examples, or more likely, I have deleted them. Caveat emptor.

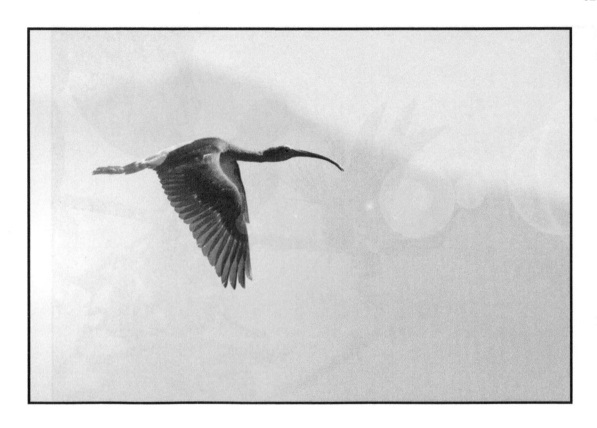

6. Chromatic aberration

Chromatic aberration occurs when the lens fails to focus all of the colors to the same point. This is more of a problem with poorer quality lens. In the example following, the "lens" was a sighting scope held against a Point and Shoot camera. For more information on this technique, see the portion on "Digiscoping". This technique is prone to this problem and the example shows unwanted cyan and magenta.

This can be reduced by increasing the focal length where possible. In can be corrected in processing by selecting the portion of the image where it occurs and desaturated for the troublesome color.

7. Noise

Noise in a photograph is the appearance of faint color speckles in an image, often green or orange in color. There are various causes like the heat generated by the camera sensor or the amplification of the background electrical. Smaller sensor cameras like many Point and Shoots are more prone to this problem.

DSLR cameras have come a long way in reducing the noise from their cameras. Five years ago, shooting at 800ISO from my Canon body generated noise in an image that I would need to deal with. In my latest Canon body this problem area is more like ISO1600 or even ISO3200.

A small portion of the following image shows a high level of noise. There are effective ways of dealing with Noise in processing an image. You will find more information on our section on Image processing.

8. Color correction needed

Unless directed, your camera makes the decision as to the White Balance in your image, and if you wish to change the result, you need to Color Correct it.

The easiest way to Color Correct an image is in the RAW conversion where you have the opportunity to adjust the White Balance.

There are also tutorials listed in our Resource Section which will show methods of Color Correction during general editing.

In the following image, the camera has made a White Balance selection which is too blue, easily corrected in RAW conversion or general editing.

9. Incorrect Exposure

One of the problems faced by new photographers is getting a proper exposure. There is a temptation to let the camera decide on the exposure but this often results in under or over exposure.

The ideal is to get in right before processing. You need to learn to adjust the exposure based on the individual scene and this takes experience. You can make adjustments after viewing the image in the view screen and re-shoot. The slang term for this is "chimping". You also need to learn your camera's metering modes and apply what is best. For example bird photography is often improved by spot metering.

Processing can improve exposure problems primarily by using the Level and Curve commands.

The following image of an American Goldfinch is slightly overexposed. It can easily be corrected during the RAW conversion, or with the editing tools in Photoshop.

10. Sensor Dust

The Laughing Gull that follows was taken at the end of a two week trip to Cape Hatteras and by that time I had accumulated a couple of stubborn globs of dust on my camera body sensor. Sensor dust is a problem of modern digital cameras and one that most photographers have had to deal with.

The first step is prevention. Dust enters when lenses are changes. Use a lot of care when you change that you try to do it in as dust free a situation as possible. Use a blower to give the sensor a squirt of air on a regular basis. Finally, don't forget to clean your lens caps, probably the main source of dust.

If you do get dust on your sensor that a blower won't remove you will need to have it cleaned. You can do it yourself (Google: Sensor cleaning) or have a camera dealer do it for you. If you do it yourself be very careful, as the sensor is delicate and a replacement is expensive.

Cleaning a dust specked image is a fairly easy matter with the dust or clone tools. Lightroom will allow you to batch this process to do multiple images at once, a function not available at Photoshop.

Image processing

Software

For many experienced photographers, Lightroom and Photoshop are essential pieces of software. Lightroom has some basic editing functions but more importantly it is an excellent database which allows you keep track of your images as well as keyword them easily. Photoshop has an an amazing set of powerful tools to edit your images.

These two programs are not inexpensive. There are alternatives. Instead of the full Photoshop, you can use Photoshop Elements, a good program but with lacking some of the functions of its big brother.

There are even free programs. One of the most fully featured is GIMP, but it is said to have a steep learning curve.

The following editing information is based on Photoshop but you should be able to find equivalents in other programs. These are just the basics, there are many other edits that may be performed on a specific image.

RAW vs JPG

RAW is a digital negative which allows for adjustments in exposure, white balance, noise reduction, image size (interpolation), saturation, contrast, levels, curves, sharpness, output resolution, bits/channel, etc. The downside is that it takes longer to process than JPG which is essentially already processed. RAW files take substantially more space on memory cards and hard drives than JPGs.

However, memory costs have dropped drastically in the last few years both for flashcards and hard drives. As well most serious photographers develop some routine of editing their images to promote their own creative vision and put their photographs in the most interesting state.

Another consideration is that using RAW format is a form of future proofing, new software editing functions may be easier

to use in this format. Landscape and fashion photographers found this out with the advent of HDR (High Dynamic Range) editing.

This is not to say that you may not successfully use primarily JPG as your camera format setting, many successful photographers have done so. However, if you have not made up your mind, I would suggest shooting RAW until you have more experience. Most DSLR allow you to produce RAW plus a JPG if you wish to hedge your bet.

Workflow

The following is a editing workflow you may find useful

Download

When you download the files from your camera, set them up in directories which have a logic which will let give you an idea of what is in them. One excellent method is to use nested directories which include the shoot date, as well as a descriptor.

The results of a shooting session of Great Gray Owl and another of Winter Ducks might be set up as follows:

2014 <Directory>
 2014-01 <Directory
 2014-01-23 Great Gray Owl <Directory>
 Image Files
 2014-01-25 Winter Ducks <Directory>
 Image Files

The strength of a system like this is that your computer will keep all of your files in chronological order by default.

Whether you use this system or another, it is important to start one as soon as possible. Trying to locate a single image among tens of thousands without one is a nightmare.

Sort and cull

After your download, pick your best images to edit and get rid of those that are not keepers. It can be useful to look at the rejects and decide what you could have done differently. This can be done in Lightroom or in Bridge which comes with Photoshop. Both databases have functions which allow you to rate and color label individual images. I find that the use of color labels makes it easy to find those images I want to edit first.

Load files for editing

As you open a file using Photoshop, it will load directly if you are using JPG. If you are using RAW format, Photoshop will start your image in its RAW converter. You can make a lot of preliminary adjustments here such as Exposure and White Balance.

If you are using Lightroom first, then you can make initial changes here. Lightroom links with Photoshop, so you can send it on from Lightroom after initial edits. Since Lightroom acts as a RAW converter, you will find it bypasses the Photoshop RAW converter when you load it through Lightroom.

Cleanup

The first step is the cleanup your image of any dust spots. Since those who check stock submissions usually do so by setting their view at 100%, I do the same. In Photoshop, examine the photo for dust spots and use the Healing Tool to quickly clean them up. Occasionally you will find the Clone Tool more useful for some areas.

You can also use Lightroom to do this. In the develop module you will find a tool to Clone out spots. Unlike Photoshop, Lightroom also has the facility to batch clean multiple files. After you edit one file, return to the Library module, select all the files you wish to clean in the same manner and hit the Sync button.

Exposure and color correction

Color correction refers to a host of adjustments to things like tonality, exposure, contrast and saturation. Editors spend years learning of the multiple functions, so a complete discussion is outside the scope of this book. However some of the following will be useful.

As mentioned, you can adjust the exposure nicely in the RAW converter in either Lightroom or Photoshop. If you decide to make changes in Photoshop after converting, you will find a variety of tools to use.

Levels is the most obvious and you can easily set the black point white point and mid-point grey with it by using the sliders under the histogram.

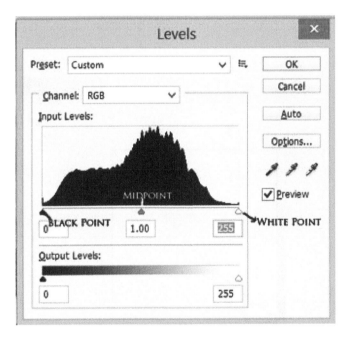

The Hue/Saturation Function is a great way to process exposure changes limited to certain colors. You can pick a certain color and adjust the exposure of that color only.

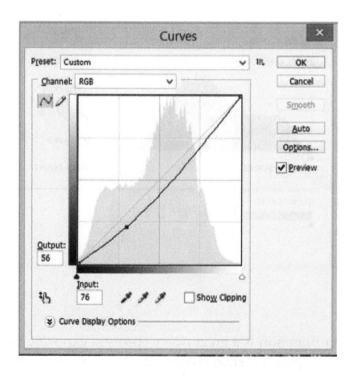

My favorite adjustment is the Curves Function. It is excellent for making subtle exposure changes. For example an image that is a bit overexposed is fixed nicely by a curve as shown in the diagram below and it is a simple matter to grab the line with your mouse and pull it down slightly to a desired exposure. It is also wonderful for creating contrast by using a s-curve. This will make a flat image come to life.

Sharpening

When sharpening an image it is important to restrict it to the areas of the image that are important. Performing sharpening across the whole image will only introduce artifacts in areas like the sky.

The first step is to use the various selection tools to restrict the areas to be sharpened. To sharpen use Filter> Sharpen> Unsharp Mask. The settings will be dependent on image size but for a web-size image of up to 1200 px on the long side, I use Amount=100 Radius=0.2 and Threshold=2. I then apply this in steps from 1 to 5 times until I am happy with the result. If set as an Action, it becomes easy to apply and to back up steps if needed.

Over sharpening is one of the common errors made by beginning editors. Common signs of this is a halo around an edge in the image. Keep in mind also that often increasing the contrast will bring an image to life better than trying to do so with too much sharpening.

Output

The output you use will be an individual choice. After editing a full size image I save it as a TIFF in LZY compression in a set of directories set up in various categories. If I am going to submit it to a stock site, I will also save it as a full size JPG as this format as this is what most stock sites accept. I will also make a web size jpg, and the same with my copyright notice on it, for various uses.

Automation

Many of the things you regularly do in Photoshop can be automated by setting up actions. Open the Actions menu, click start new Action and name. After performing the functions you want, press stop recording. You're all set to repeat it on another image with one click to play the action.

By planning your workflow and setting up suitable actions, you will drastically reduce your editing time.

Storage and backup

A busy photographer soon builds up huge numbers of files that need to be stored and protected. I use large large external hard drives, currently 4 terabyte drives are available for a reasonable price. When my computers eventually dies, and they always do eventually, its a simple matter to move the drive to a new computer.

For backup, I use two other sets matching the active drives. One set is backed up regularly and kept on site. Periodically I exchange this first set of backups with a second set which are kept at a safety deposit box at my bank. This second backup is then brought up to date with the active drives. Some photographers change the media type on some backups by using things like DVDs but this is becoming an increasingly problematic solution as file sizes have increased.

Selling Your Images

One of the first things you need to realize if it is your intent to sell your images is that you are embarking on a well trodden path. With the arrival of the digital camera, many thousands of photographers have tried it, and because the digital age has made display and delivery of digital files easy and inexpensive, it has increasingly become a buyers market. At one time a buyer would expect to pay hundreds of dollars for use of a bird image, where now it can be obtained for a few dollars or even for free.

In order to sell your images at a premium on a regular basis, it is necessary that your images stand out from the thousands it may be competing against. It needs to be well exposed, unobstructed and well edited. Even more, it needs to be as original as possible, to show unusual behavior or taken creatively. There are still buyers willing to pay reasonable fees, but they need to be given top images to buy.

Displaying and basic marketing of your work

It is important to have an internet presence to show your images. Consider this your virtual gallery and basic marketing.

Blog

A blog is a great place to introduce your images on a regular basis and to attract and interact with those who are interested in those images. Free software like Blogger or Wordpress makes creating a visually attractive blog very easy. Posting articles which are interesting and helpful on a regular basis will attract attention to your site. If you deliver information that you find fun and informative, it will be received better than simply trying to push for sales. Take advantage of things like tagging and categories in order to make your articles as search friendly as possible. You are not just presenting an immediate post, you also want it found in searches months and years from now.

Online Gallery

An easily navigated, attractive online gallery can be an important asset. It is not expensive to put a variety of your images on your own site at places like Flickr, Smugmug and PBase. See our Resource section.

When you first start out, it is natural to want to display a lot of images of a wide variety of species. As you gain experience and your images improve, consider culling some of these older images. You want to display a high level of desirable images.

Social Media

Its no great secret that Social Media sites like Facebook and Twitter have exploded in popularity in the last few years. For a photographer, they can offer an easy path to increased recognition. There are potential problems though. If you are only trying to sell something, it will turn people off quickly. You need to interact in a friendly give and take way. Therein lies another problem. It is easy to spend a lot of time with Social Media sites to the detriment of other things you need to do.

Putting it all together

Many successful photographers use their personal website or blog as a hub to feed their social media sites. It is easy to have posts automated to automatically post to their Social sites and then to supplement them with regular visits. They also cross link all of these sites as much as possible. For example their blog will have links to all their social media pages as well as their online galleries.

Where to sell images

Magazines and brochures

At one time there where a good number of magazines devoted to birds, and they were a steady market for bird photographers. With the more birders getting information online, the number of magazines has dropped dramatically. Look in our Resources section for current magazines who pay for images.

Selling Prints

As your images get more exposure, you will often find that you get requests for prints. If you decide that you want to promote these sales, you need to choose whether to print them yourself, or use a Print on Demand service.

If you Print them yourself, you need have a suitable printer and become proficient with it. Additionally if you include mattes or framing, you need to be able to produce them or shop it out. You are also going to have to learn about packaging to deliver the product in a pristine condition. The upside is that you will get a much larger slice of the sale price.

Ideally a Print on Demand service will take most of the work out of your hands and deliver you some reasonable portion of the sale price. Our Resource section has information on a number of Print on Demand services.

Stock Sites

There are a multitude of stock sites where you can become a contributor, and hopefully make sales. Look in our Resource section for a list. There are a number of things you want to evaluate when choosing a stock site.

What is the range of prices and what is the percentage of that price you receive, your Royalty? The sad truth is that many of these sites sell your images at very low price and you need to make a great many sales to make a reasonable income. I know of a very good photographer who had been with one of these for over a year and had spent a lot of time submitting and key wording files. To that point he had made less than $100 for his efforts and was very discouraged. Consider whether a "Penny Stock" site is right for you.

How reasonable is it to work with a particular site? Do they make arbitrary decisions? Do they set large scale secondary sales which allow use of your photos but pay you very little? Check their community forums and find out the contributors problems are, keeping in mind that forums often attract their share of cranks or complainers? Some stock sites ban those who complain about their methods, so be wary if there forums contain no criticism.. Do a web search on the stock site as well to root out possible problems.

Exclusive or Non-exclusive. If you submit files to a site, can you submit the same files to other sites? Often you get a choice with exclusive contracts paying a higher royalty then a non-exclusive. If you are just starting out with stock submission, be very wary of tying yourself into exclusive contracts. You can always do so after you have some working experience with various sites.

Expanding your stock selection

Nature photography in general and bird images in particular, are a very saturated market. You may even find that some stock sites will be less willing to have you as a contributor if you are exclusive to this genre. If you become familiar with what is popular with sellers, you may find plenty of opportunities to make other types of images during the time you spend making images of birds. If you develop this expanded approach, you will find yourself with a lot more images for stock submission.

Video

Most digital cameras have the ability to record video and the better ones record 1080HD. However you face different challenges then those you do when taking photographs. As previously discussed, you want to take a variety of photos when you have a cooperative subject and there is no reason not to add video clips to this list.

Camera shake

When taking photos, you can handhold the camera and lens as long as the shutter speed is fast enough to prevent blurring. This requires a steady camera for less than a second. With video, a quality output requires a stationary camera for the length of the video clip, often over 10 seconds. This normally requires using a tripod. Even when using a tripod, wind can often cause problems with shaky footage, and you may need to shelter your equipments.

Cropping

With photographs, you can severely crop an image and end up with a useable photo, especially for use on the web. It is a different story with video. Even a 50% magnification will cause a clip to start to deteriorate. It makes it all the more important to get close to your subject when shooting video.

Exposure

One of the common problems with video output, is that the sky or other light areas may be overexposed when the subject is properly exposed. This may occur with photos as well but usually an editing fix is easier with that medium. An in camera solution is the use of Graduated Neutral Density (ND) filters. These are optical filters which reduce the light transmitted to a portion of the sensor. Typically it will have one half clear and the transition area graduated. A filter holder attached to the front of the lens and allows movement of the filter to best reduce the area required.

Filter holder with a +2 Neutral Graduated Filter attached

Editing Software

You will need software specific to editing of video. Some excellent commercial programs are After Effects and Premiere Pro from Adobe, Sony Vegas, and Final Cut which is used on a MAC.

Ethics

Our first step may be to give some thought about our personal approach towards nature photography. Like many things in life, how we go about it is more important than the results. I am certain that our attitude towards these creatures is the main factor in the results we achieve.

"First do no harm". It is a slogan used by the medical profession which emphasizes the priorities of that work. If you are going to photograph wild creatures you need to have this same attitude. Here are some ideas to consider:

1. **Protect Birds and their environment**

Don't expose birds to danger and avoid stressing them. removing twigs and other obstructions around nests to get a clear view helps predators get a clear view as well.

Use recordings to attract birds sparingly, if at all. never use them with species which are rare in your area or of Special Concern. In heavily birded areas, your use may be adding to the cumulative use by others.

Keep well back from nesting birds, taking your cue from the adults reactions. The use of telephoto lenses can minimize disturbance.

Use flash artificial lighting sparingly.

2. **Respect the rights of others**

Don't enter private property without permission.

Keep to existing trails where they exist and keep the disturbance of the habitat to a minimum.

3. **Be a Positive Force**

Practice courtesy for other birders and non-birders and you will generate goodwill.

Take on a cause, large or small. Many years ago I was on a boat tour in Tierra del Fuego which stopped at an uninhabited island. The guide carried a plastic bag with him and picked up everything that didn't belong. It didn't take a lot of effort but it impressed me and I often follow his example.

If you find a rare bird, especially one nesting, evaluate before reporting it to Rare Bird Alert systems. Will it would attract enough visitors to disturb the bird or the habitat?

4. Manipulation of subjects

Live baiting is a controversial practice and one in which many people have strong opinions. One of the more common baiting practices is luring in Northern owls through the release of wild mice. I personally won't use it but it is something each photographer must make his own educated decision on. Keep in mind that there is probably no other subject which causes bad press for nature photographers from the general public than live baiting.

Captive subjects are another hot topic. I have no problem with captive subjects where they are being well kept but, again, this is a personal decision for each photographer.

5. Manipulation of Images

Manipulation of images has occurred from as long as there were images to adjust, and arguments over it seem to have been around just as long. In a general way, its up to the photographer or editor unless it is done in a fraudulent manner, such as breaking contest entry rules. As a practical matter, your goal will often be to keep an image looking realistic which precludes too much manipulation.

Resources

Books

A Guide to the Nests, Eggs, and Nestlings of North American Birds, Paul C. Baicich and Colin J. O. Harrison

Peterson Field Guide: Eastern Birds' Nests by Hal H. Harrison, Roger Tory Peterson, Mada Harrison and Ned Smith

A Field Guide to Western Birds' Nests by Hal H. Harrison, Roger Tory Peterson and Mada Harrison

Peterson Field Guide to Birds of North America (Peterson Field Guides) by Roger Tory Peterson and Lee Allen Peterson

The Sibley Guide to Birds by David Allen Sibley

Birds of Europe: (Second Edition) (Princeton Field Guides) by Lars Svensson, Dan Zetterström and Killian Mullarney

Birds of East Asia: China, Taiwan, Korea, Japan, and Russia (Princeton Field Guides) by Mark Brazil

Birds of Central Asia: Kazakhstan, Turkmenistan, Uzbekistan, Kyrgyzstan, Tajikistan, Afghanistan by Raffael Ayé, Manuel Schweizer and Tobias Roth

The Field Guide to the Birds of Australia 9th Edition by F Knight, G Pizzey and S Pizzey

Birdfinder: A Birder's Guide to Planning North American Trips (Aba Birdfinding Guide)

Nature Photography Forums
Naturescapes
http://www.naturescapes.net/

Birdforum
http://www.birdforum.net/

Nature Photogaphers
http://www.naturephotographers.net

Birdphotographers
http://www.birdphotographers.net

Camera Equipment
B&H Photo
http://www.bhphotovideo.com

Henry's
http://www.henrys.com

Allen's camera
http://allenscamera.com/

Digital Discount
http://www.mydigitaldiscount.com

Amazon
http://www.amazon.com

Adorama
http://www.adorama.com

Digiscoping Resources
Digiscoping- Yahoo Group
http://groups.yahoo.com/neo/groups/digiscopingbirds/info

Window Mounts
Kirk Window Mount
http://www.kirkphoto.com/Kirk_Window_Mount.html

L.L. Rue Groofwin Pod
http://www.rue.com/index.php?main_page=index&cPath=4_5

Phototraps
Phototrap
http://www.phototrap.com/

Pelagic Trips
North America – East Coast
Seabirding Pelagic Trips with Brian Patteson
http://www.seabirding.com/
Telephone: (252) 986-1363

See Life Paulagics with Paul Guris
http://www.paulagics.com/
Telephone: (215) 234-6805

Brookline Bird Club
http://www.brooklinebirdclub.org/

North America – The Florida Keys and Dry Tortugas
South Florida Birding with Larry Manfredi
http://www.southfloridabirding.com
Telephone: (305) 247-3960

Victor Emanuel Nature Tours (VENT)
http://www.ventbird.com/
Telephone: (800) 328-8368

North America –West Coast
Westport Seabirds
http://www.westportseabirds.com/
Telephone (360) 268-9141

The Bird Guide, Inc.
http://thebirdguide.com/pelagics/
Ttlephone: (503) 680-2405

Shearwater Journeys with Debra Shearwater
http://www.shearwaterjourneys.com/index.shtml
Telephone (831) 637-8527

Monterey Pelagic Seabirds
http://www.montereyseabirds.com/
Telephone (831) 375-4658

South America
Kolibri Expeditions
http://www.kolibriexpeditions.com
Telephone: (511) 4765016 – From the US – call 011-51-1-476 50 16. Cell: 99331669

Far South Expeditions
http://www.fsexpeditions.com/mainland_chile/pelagic_trips_off_valparaiso.php
Telephone +56 61 261-5793

Ushuaia, Tierra Del Fuego
There are some excellent trips leaving from the main wharf out into the Beagle
Channel, ranging from
3 to 8 hours.

Europe
Birding Madeira
http://madeira.seawatching.net/index.html

The Northern Ferries
There are a number of ferries, particularly in the northern parts of Europe, which would provide excellent seabird viewing
opportunities.
I have taken the ferry to the Orkney Islands many times, and it passes through rich bird area including Auks, Skuas, Storm
petrels and Shearwaters.

Africa
Cape Town-Zest for Birds
http://www.zestforbirds.co.za/
Telephone: +27+21+557-0624

Anne Albatross Cape Pelagics with Anne Gray
http://www.annealbatross.org/

Cape Town Pelagics
http://www.capetownpelagics.com
Telephone +27 (0) 21 650 3306 Cell +27 (0) 73 675 3267

Australia and New Zealand
Wollongong and Southport Pelagics, Australia
www.sossa-international.org
Telephone +61 (02) 4272 4626

Albatross Encounter with Ocean Wings, New Zealand
http://www.albatrossencounter.co.nz/albatross/ocean_wings/
Telephone: 0800 733 365

Pterodroma Pelagics, New Zealand
http://www.nzseabirds.com/
Telephone: +64 9 422 6868

Wrybill Birding Tours, New Zealand
http://www.wrybill-tours.com/index.htm
Telephone: +64 6 877 6388

Photoshop Tutorials
Nature Notes
http://www.ontfin.com/Word/photoshop-tutorials/

Birding magazines
Alula
http://www.alula.fi/

Birds and Blloms
http://www.birdsandblooms.com/

Birdwatch
http://www.birdwatch.co.uk/

Bidwatching
http://www.birdwatchingdaily.com/

Birdwatching (U.K.)
http://www.birdwatching.co.uk/

Birding
http://www.aba.org/birding/

Bird Watchers Digest
http://www.birdwatchersdigest.com/bwdsite/

Birding World
http://www.birdingworld.co.uk/

British Birds
http://www.britishbirds.co.uk/

Dutch Birding
http://www.dutchbirding.nl/

Ornithos
http://www.lpo.fr/

L'Oiseau Mag
http://www.lpo.fr/

World Birdwatch
http://www.birdlife.org/how_to_help/world_bird_club/index.html

Print on Demand
Redbubble
www.redbubble.com

Lulu
www.lulu.com

Cafe Press
www.cafepress.com

Society6
www.society6.com.

Online gallery
Flickr
Smugmug
PBase

Social media
Facebook
Flickr
Google+
LinkedIn
Pinterest
StumbleUpon
Tumblr
Twitter

Stock sites- There are 100 of sites which may sell your photos and videos. Here are just some of them

Alamy
http://www.alamy.com/
Alamy maintains high standards for contributors for their site but they command good prices and pay reasonable royalties.
Thier method of enforcing high standards is to reject an entire batch of submissions if they have a problem with any file in
the submission. While this can be a bit annoying it will make you more critical of your own images and a better editor.

Getty Images
www.gettyimages.com
This is probably the most well known stock site in the world and the one that photographers who are looking at stock submission often look to first. They also own other sites like the "penny stock" site iStockPhoto.com. If you think you may want to work with them, do your homework first. You will find that they pay a very low royalty rate, usually 20-30%, and many who have worked with them are unhappy with how they have been treated.
Getty Images also have an arrangement with Flickr to offer their users a sales outlet for images. Keep in mind that the images will be cherry picked by Getty, they will only offer to deal with a small portion, they pay a low royalty, and they require exclusivity so that they cannot be sold elsewhere. Its difficult to see how this can be advantageous to the photographer if he considers using stock sites as a meaningful money stream.

Pond5
https://www.pond5.com
They deal in both video and photos. You set prices but they tend to be lower.

Shutterstock
http://www.shutterstock.com/
They deal in both video and photos. You set prices but they tend to be lower.

Revostock
http://www.revostock.com
Video only, easy to work with.

FootageSearch
http://www.footagesearch.com/
Video only, and more nature oriented.

Glossary

Aperture
Aperture refers to the diaphragm opening in a lens. It controls the amount of light that passes through to the sensor.

Archiving
Archiving is a process of making copies of your images and storing them in a different physical location.

Artifacts
Artifacts refer to undesirable changes in a digital image as a result of sensor and optic limitations, image processing by the camera, subsequent editing and file compression. Following are some common artifacts:

Aliasing- refers to visible steps on diagonal lines.

Blooming- Blooming is a result of a pixel being overloaded or overexposed and the charge flowing to neighborhood pixels causing loss of detail

Chromatic aberration- results when the lens focuses different wavelengths on different focal planes resulting in color fringes.

JPG Compression- A method of reducing file size by dealing with blocks of pixels, as the compression increases, so do the artifacts

Moiré- a wavy pattern that appears in areas of repetitive detail.

Sharpening halos- Sharpening software works by increasing the contrast between edges. Overuse will produce a light halo next to the darker surface.

Backlighting
When the subject is between the light source and the camera, the bird will be backlit. This can cause great difficulties in correctly exposing the subject. It can also be used for creative images such as silhouettes.

Bracketing
Bracketing is a method of ensuring a correct exposure by taking a series of images with the expected correct exposure, one underexposed and one overexposed. Most DSLR can be set to do this automatically.

Brightness
The intensity of the level of light. It is one of the dimensions of color in the HSB color system, along with Hue and Saturation.

Buffer
A cameras temporary storage space where images are held until processed and written to memory card. When the buffer becomes full, the camera has to pause taking new images until it empties enough space.

Burst Rate
The burst rate is the number of frames per second a camera can take.

Calibration
A process of adjusting one device such as a monitor so that it works consistently with another such as a printer

Clipping
When the exposure is long enough to to fill a photosite it records its maximum value. And detail is lost. This is known as clipping.

Cloning
Cloning is a photo editing process where pixels are duplicated from one part of the image to another part.

Color Gamut
The color range that can be produced by a device such as a printer or monitor

Color temperature
A method of describing light color differences ranging from Red (1900 Kelvin) to Blue (10,000 Kelvin)

Compression
Techniques for reducing file size. Some processes like LZW for Tiff format don't discard information, while others like JPG format do discard information and are termed as lossy.

Contrast
Contrast refers to the range of tones in an image from darkest to lightest.

Cropping
Cropping an image involves removing unwanted areas of the image leaving only the portion desired.

Depth of Field (DOF)
Depth of Field is the distance behind and in front of the point of focus in which the scene is still in focus.

Diffusion
Describes a situation where the light rays are scattered by things like clouds and mist, softening the light and lessening shadows.

Feathering
In photo editing it refers to the fading of an edge of an image or selection. In camera operation it can refer to feathering of the focus while taking flight images.

Fill Flash
Fill Flash uses an external flash to supplement natural light to reduce shadows and increase detail.

Filter
A thin transparent disc placed over a camera lens to modify the light passing through. There are also editing functions which mimic these effects.

Focal Length
The focal length is the distance from the optical center of the lens and the point of focus with the lens focused on infinity.

Focus
That point where the light rays converge on the sensor to produce the sharpest image.

F-Stop
The measurement of the aperture size of a camera lens.

Gigabyte
A measure of memory or data equal to 1,000 megabytes

Halo
A bright border on an edge caused by over sharpening or over compression.

Histogram
A map of the distribution of pixels in an image. The horizontal line goes from dark to light tones while the vertical line represents the number of pixels in the range.

Hot-shoe
A fitting for accessories on a digital camera, usually used for an external flash.

Hue
The color based on its position in the color spectrum.

ISO
A measurement of film speed, the film is faster as the rate increases.

LCD (Liquid Crystal Display)
A flat screen display found on many digital cameras which gives a thumbnail view of images as well as other functions.

Megabyte
A unit of data or memory equal to 1,024 bytes.

Noise
A random pattern of small spots formed by electrical signals.

RAW
A digital image that retains camera data and can be highly adjusted before significant degradation. It is sometimes called a digital negative.

Resolution
The level of detail in an image measured in DPI (Dots per inch) or pixels.

Saturation
The strength of a color going from a light tint to a deep saturated tone.

Shutter
The mechanism which controls the length of time of an exposure.

Shutter Speed
the amount of time light is allowed to be exposed to a sensor or film.

Index

Lightning Source UK Ltd.
Milton Keynes UK
UKOW06f0619130215

246169UK00007B/43/P